The
Book of
Happiness:
Africa

The
Book of
Happiness:
Africa

Joseph Peter

SPIEGEL & GRAU

NEW YORK

Published in the United States by Spiegel & Grau, an imprint of The Random House Publishing Group, a division of Random House, Inc., New York.

SPIEGEL & GRAU and Design is a registered trademark of Random House, Inc.

Library of Congress Cataloging-in-Publication Data
Peter, Joseph.
The book of happiness: Africa / by Joseph Peter.
 p. cm.
ISBN 978-1-4000-6961-3
eBook ISBN 978-0-679-64540-5
1. Africa—Social life and customs—Pictorial works. 2. Portraits, African.
3. Happiness—Africa—Pictorial works. 4. Peter, Joseph—Travel—Africa. I. Title.
DT4.5.P47 2012
960—dc23 2011052862

Printed in China on acid-free paper

www.spiegelandgrau.com

9 8 7 6 5 4 3 2 1

To my mother,

who encouraged me to believe in the beauty of my dreams

and who taught me that anything is possible.

You are one of the most optimistic people I know.

My gratitude knows no bounds.

To my father,

my coach, my mentor,

who first brought me to see the World Cup Trophy

and changed my life.

Thank you for the values I have today and the gift of unconditional love.

Foreword

I was very impressed when I met Joseph Peter in Johannesburg during the 2010 FIFA World Cup in South Africa. He caught my attention when he told me that he had just completed an unprecedented journey across Africa, fifty of our fifty-three nations in seventy-five days, with the FIFA World Cup Trophy Tour by Coca-Cola. He had created a special book for the World Cup in Africa and its legacy.

At first, I thought that because he was touring with the trophy, with so much security, he might not have been exposed to the real Africa and its most treasured component, its people. However, as the conversation progressed, he explained that the specific objective of this tour was to celebrate Africa and inspire the African people. He had captured images that focused on the "inherent optimism and happiness" of our people. These images became a way to share this positivity with the rest of the world. He expressed to me what I myself feel is so amazing about our continent, about this new view of Africa Rising: the openness and warmth our people have, especially when meeting foreigners or strangers. No matter how much abject poverty, struggle, and hardship we have been exposed to, we remain centered in the values that make us uniquely human, centered in humanity. Humanity began in Africa; we are the

cradle of civilization, the cradle of positivity; we endure always; we rise up.

Coming as we were from a history that has seen so much Afro-pessimism around the world, it was at this juncture, this challenge to host the World Cup, that we rose to the occasion and showed the world what we were capable of. The World Cup has come and gone, and I stand proud to say to the world, "Mission accomplished!" We broke down many misconceptions that have clouded our continent for so long. At the beginning of a new decade, we as Africans recognize that this is the beginning of a journey that will lead us into a world in which Africans can stand proud alongside the citizens of the world as equals. There is much work to be done in promoting and harnessing a positive image and spirit that will ultimately lead to the creation of an environment in which Africans around the world contribute to the continent's progress and prosperity.

We at Africa Rising (an organization dedicated to promoting a positive image of Africa around the globe) feel that it is people like Joseph Peter who make sure this hopeful African story gets told. *The Book of Happiness: Africa*, in our eyes, is one of many positive initiatives that we would like to support and share with the rest of the world. In the words of my grandfather, Nelson Mandela, "People need inspiration in order to change."

May this book inspire the world to see a positive Africa for 2012 and beyond.

Together we stand, divided we fall,
Ndaba Mandela
Chairman and co-founder,
Africa Rising Foundation

Introduction

When I was thirteen, my father took me to see the FIFA World Cup Trophy in Boston during its tour around the United States for the 1994 FIFA World Cup USA. As an aspiring soccer player, I found it a moment of pure inspiration. It was also the beginning of an adventure that would take me around the world, playing professional soccer and immersing myself in different languages and cultures. Since that day I have always thought of the World Cup Trophy as more than a sporting icon. It is a symbol of unity and hope, and a common source of happiness that has brought billions of people together.

Nineteen years later, it was no longer my feet that were taking the shots, but my fingers. The passion and energy I had put into sport found a new focus in photography. I had left soccer behind (or so I thought), though my love of travel remained constant. In July 2009 I found myself in Istanbul, taking photographs in the lively Fener district. I had just taken a photograph of a young girl smiling in a crowded marketplace. Looking down at the camera screen, I suddenly felt a radiance emanating from the image that changed everything I was feeling at that moment. The happiness on the face of this child was infectious. I kept returning to that

image as the day progressed, and it stirred a curiosity in me about the effect the smile of an unknown face can have on you.

Later that night, over a drink with a friend, the conversation turned to the upcoming World Cup, which was being held in South Africa. I was reminded of the joy the trophy had inspired in me all those years ago and the joy it would bring to the hundreds of millions of soccer fans across the African continent. Nelson Mandela had traveled to FIFA headquarters in Zürich to win the World Cup bid. I was seized with the desire to capture this historic tidal wave of joy. The purpose of this mission became clear to me in an instant, and it would be guided by my two loves: soccer and photography. The vision of happiness I had seen on the face of that little girl in the Turkish market not only inspired the journey, but also has given direction to my work and my life ever since.

By an extraordinary stroke of luck and some quick maneuvering, within three weeks' time I'd joined the FIFA World Cup Trophy Tour by Coca-Cola as it made its way across the continent. The tour covered fifty countries in seventy-five days. Every day I lost more legroom in our small plane to the bulky equipment needed to store the images on my camera. By the end of the trip I had taken about 150,000 photos. Every time we touched down in a hosting country, people flocked to see the trophy. Hosting the World Cup tournament was an immense honor for South Africa and a source of great pride for all Africans. As I followed the trophy I saw that Africa had the perfect terrain for soccer fields, great athletes for players, and the most spirited supporters for fans. I captured the faces of presidents, heads of state, soldiers, workers, and children. *The Book of Happiness: Africa* named itself, because this emotion was what I saw hundreds of times a day through my camera lens.

I am not the first photographer to have a love affair with this continent. Its colors, diverse landscape, fierce beauty, and wildlife are well recorded in the pages of newspapers and books. But what I saw during the World Cup tour was unique to my eyes: a glorious vision of relentlessly positive images of the people of Africa. Without a doubt,

many, many places on the continent are plagued by the tremendous challenges of staggering poverty, violent conflict, and all sorts of hardship. But I was fortunate enough to witness the generous, loving spirit of the people and an inherent wellspring of hope. When K'naan took the stage in Uganda to perform "Wavin' Flag," it started to rain heavily. Not one person left the stadium. This is the African spirit. My heart remains forever open and grateful for these memories.

The day after the World Cup final, one year to the day after I took the photo of the girl in the Turkish market, I had the privilege of presenting the first copy of *The Book of Happiness: Africa* to Nelson Mandela at his home in Johannesburg. It was one of the most humbling experiences of my life. The original copies of the book were handmade. I used materials collected during the tour—fabrics, old papers, inks, paints, and leathers—to accent the images. A special edition was auctioned in South Africa at the Mandela Foundation gala, raising $15,000. Various heads of state, United Nations officials, FIFA officials, CEOs, and celebrities have since been given copies of the book, with the intention of sharing these too-seldom-seen positive images of Africa.

The book you hold in your hands is the first edition for the general public. A portion of the proceeds of each sale will go back to the continent, via a partnership with the Coca-Cola Africa Foundation, to benefit the people that the beautiful faces in these portraits represent.

Nelson Mandela once said that people need inspiration to change. It is my wish that every smile in *The Book of Happiness: Africa* inspires people like us to make change.

To the African people, you have my unending gratitude. My soul is forever changed.

Joseph Peter
New York City
April 2012

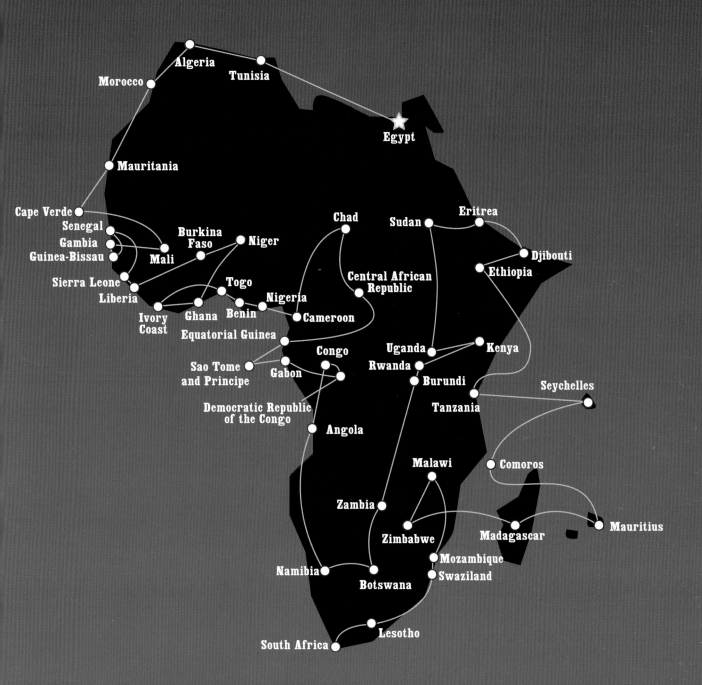

The
Book of
Happiness:
Africa

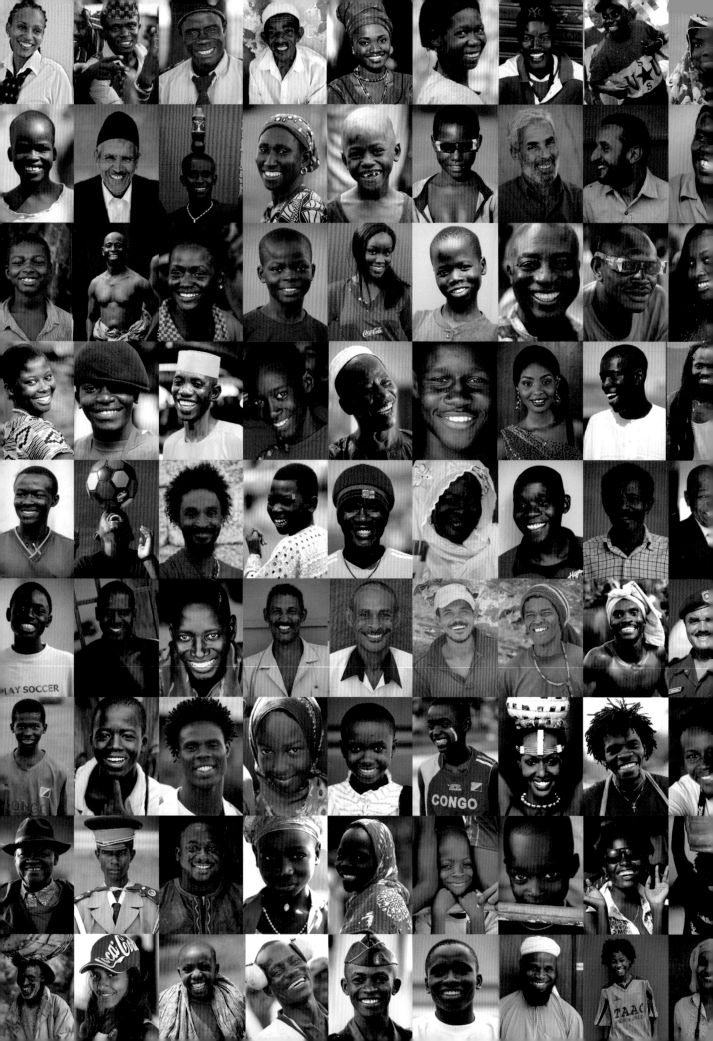

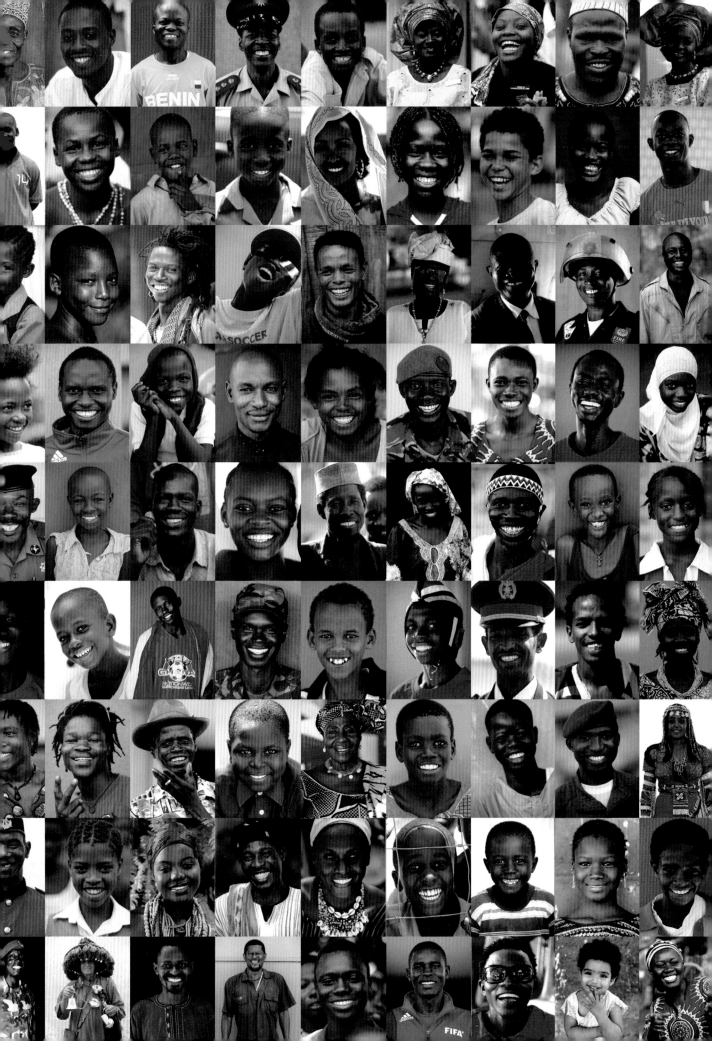

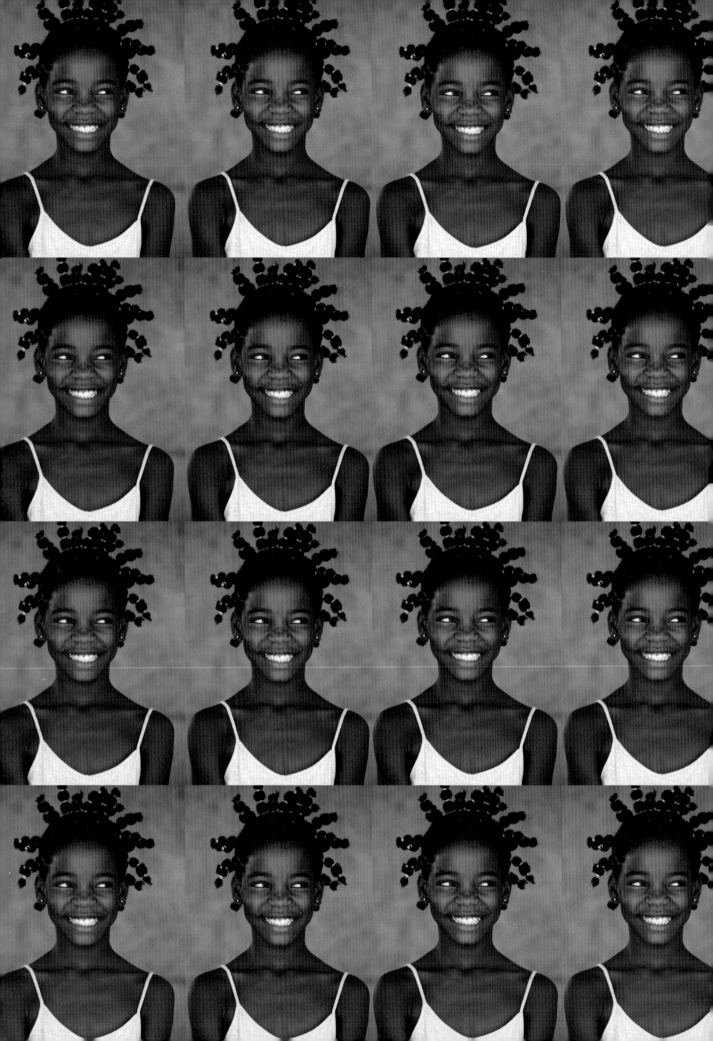

What is happiness?

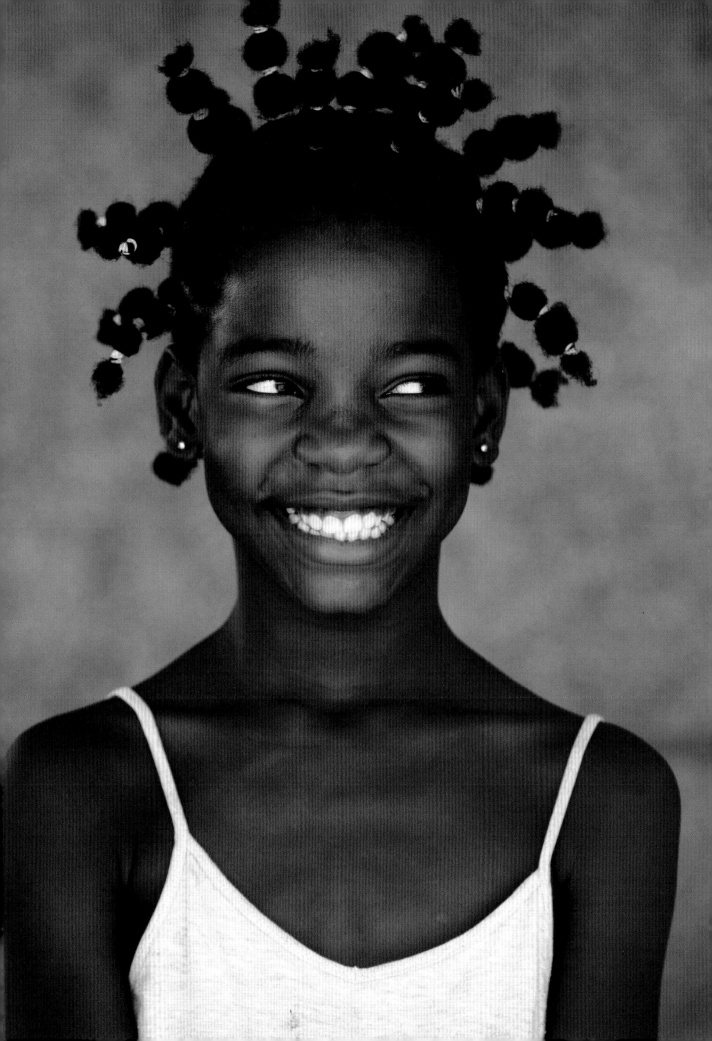

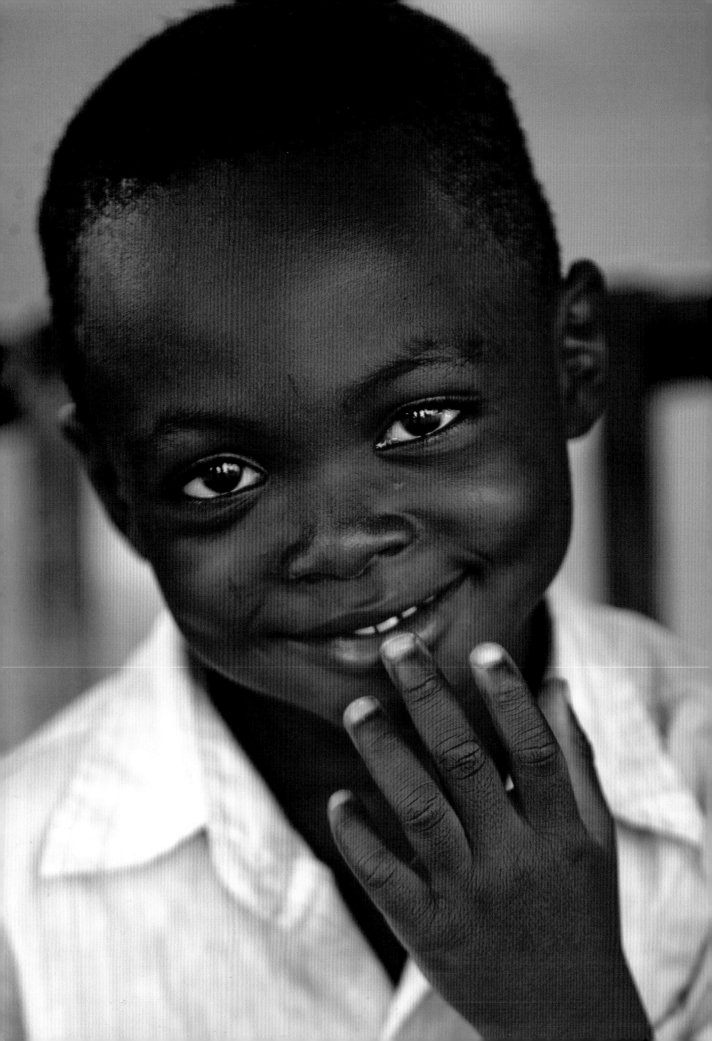

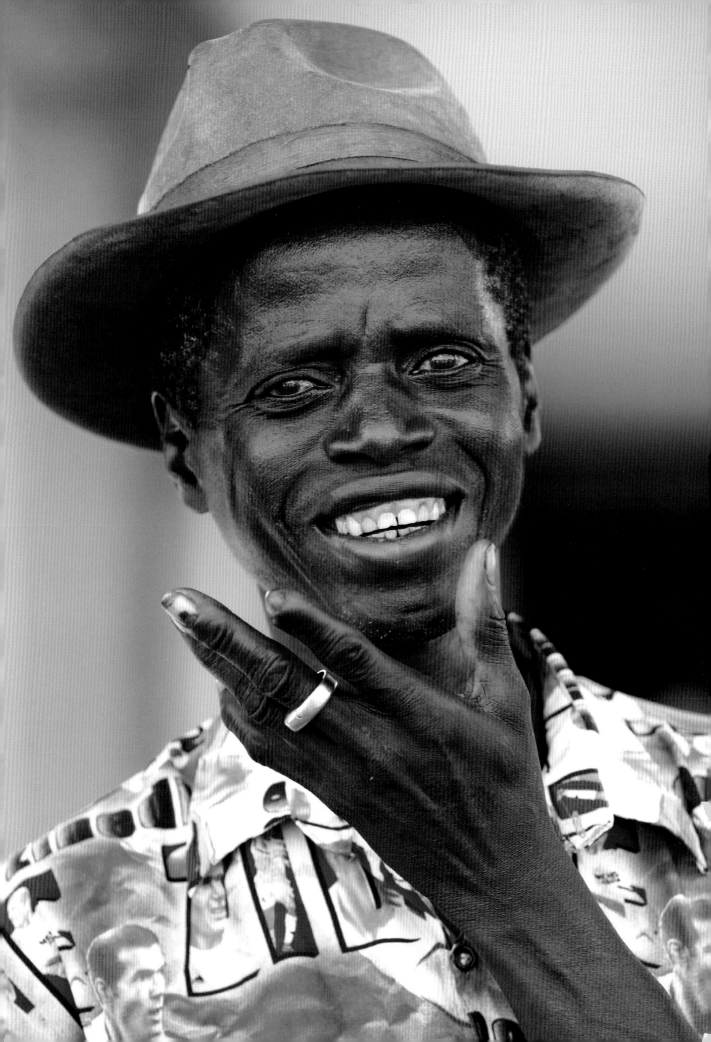

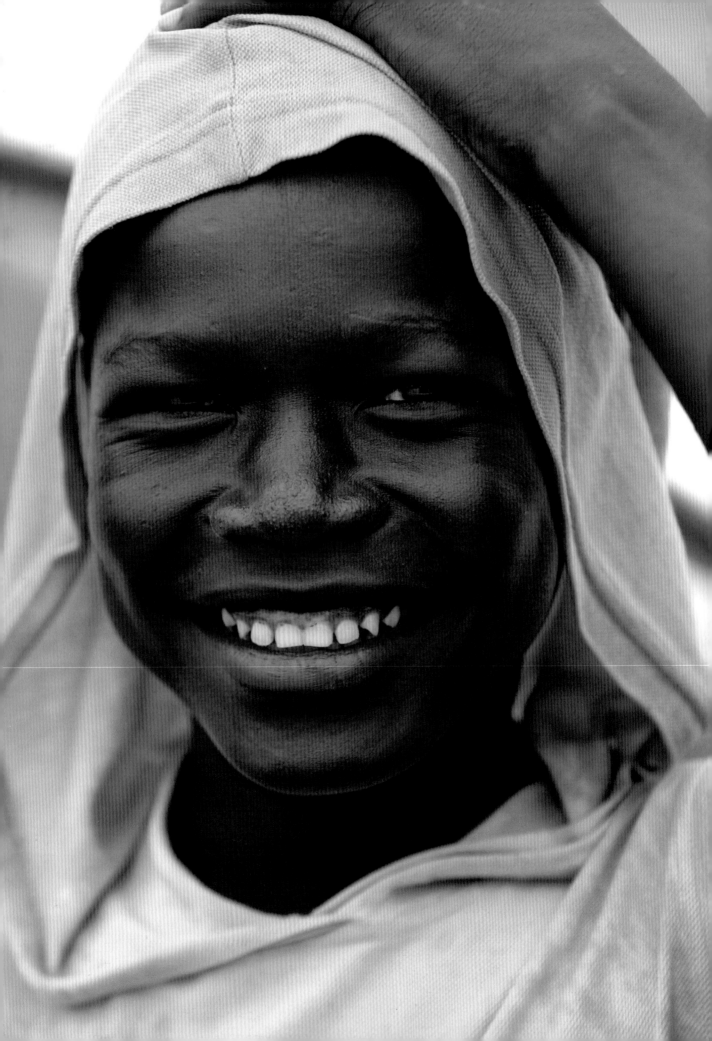

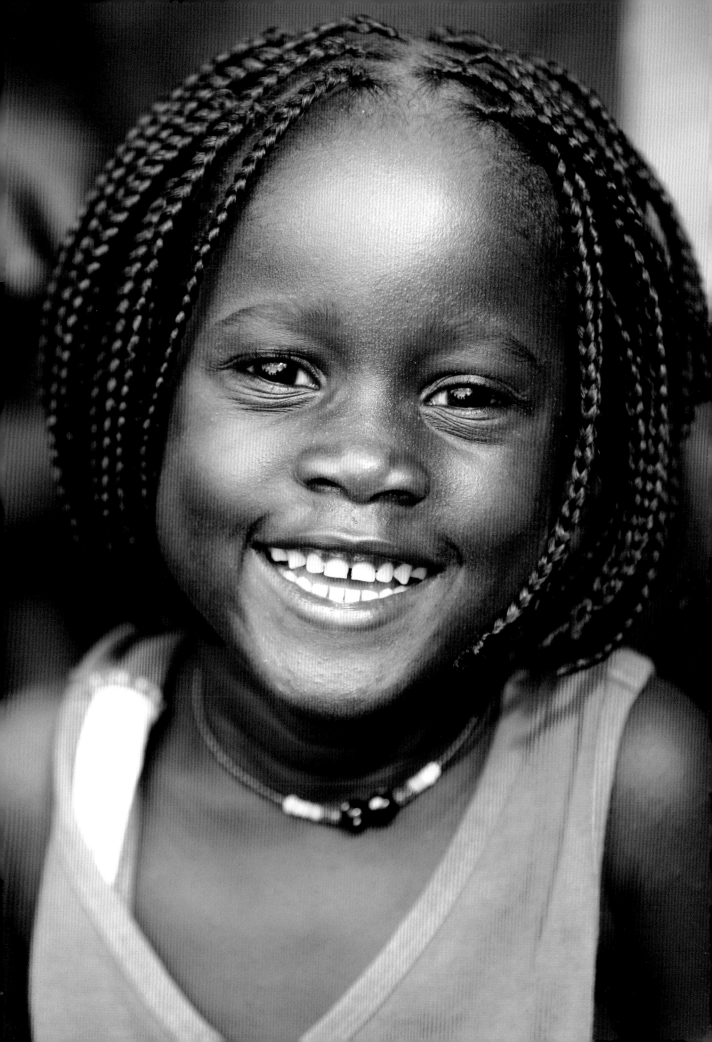

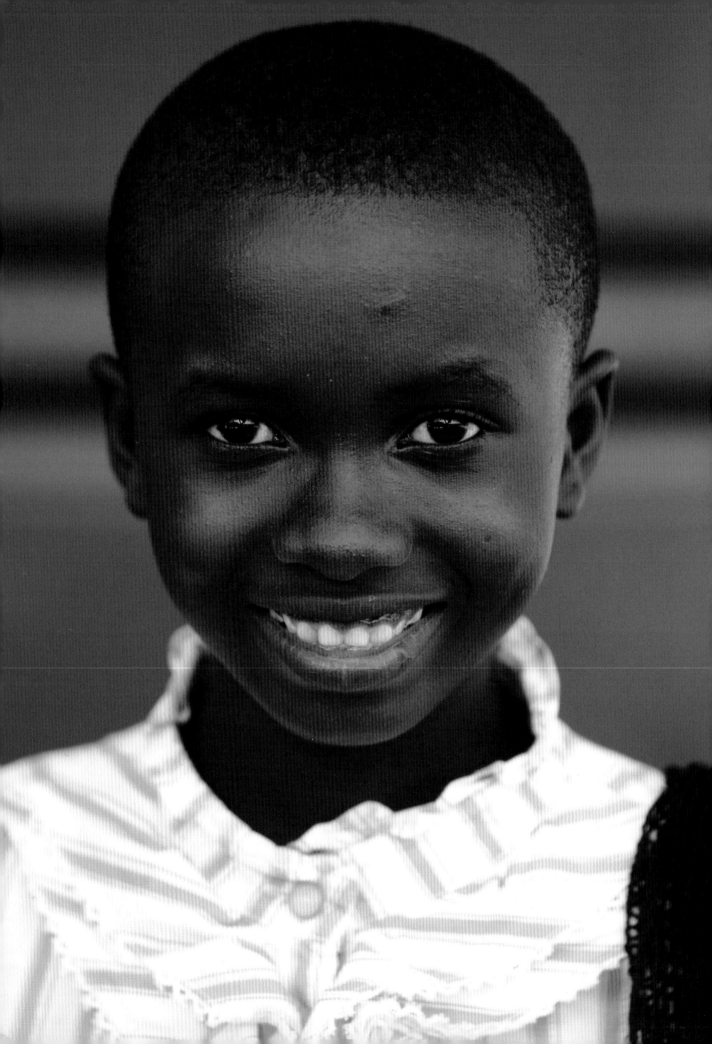

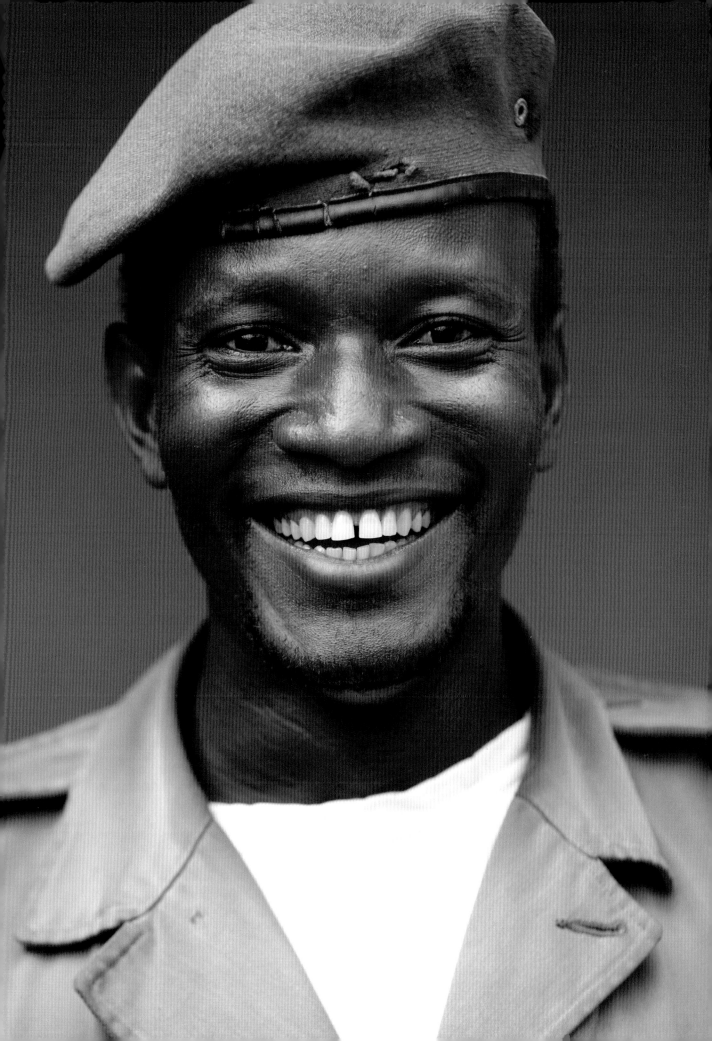

Happiness
is a state
of mind

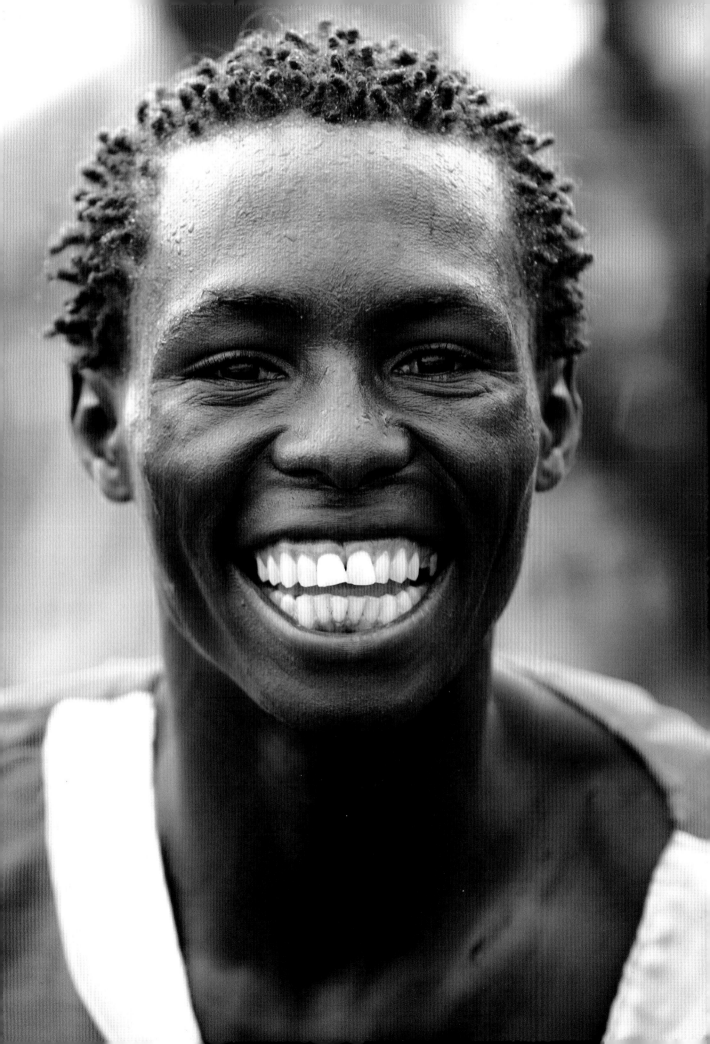

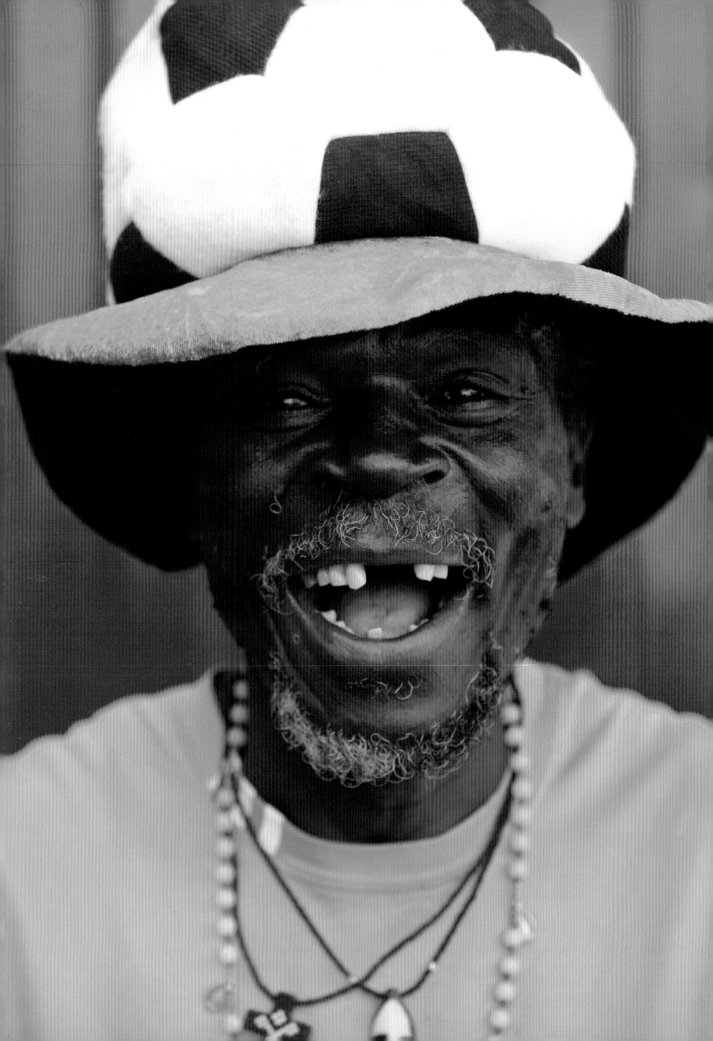

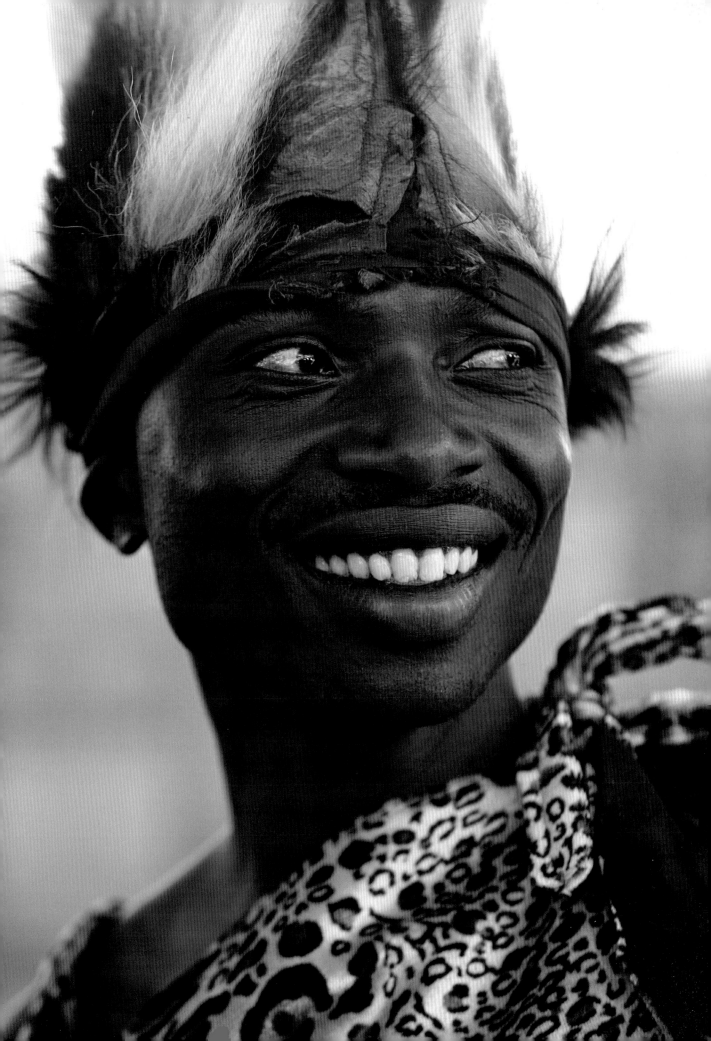

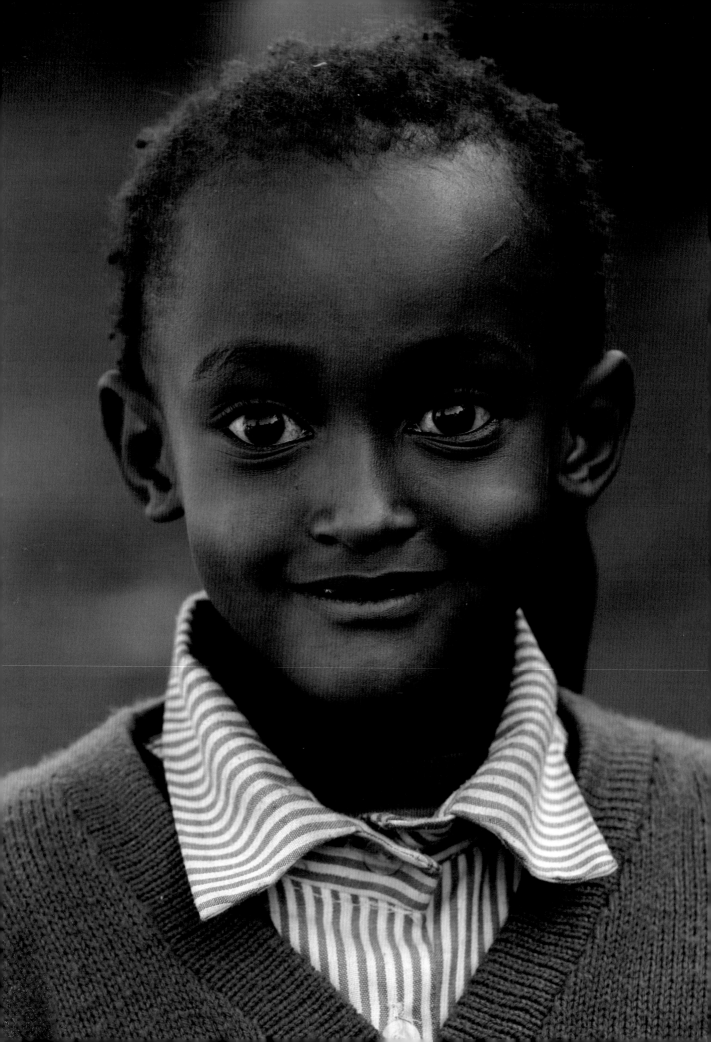

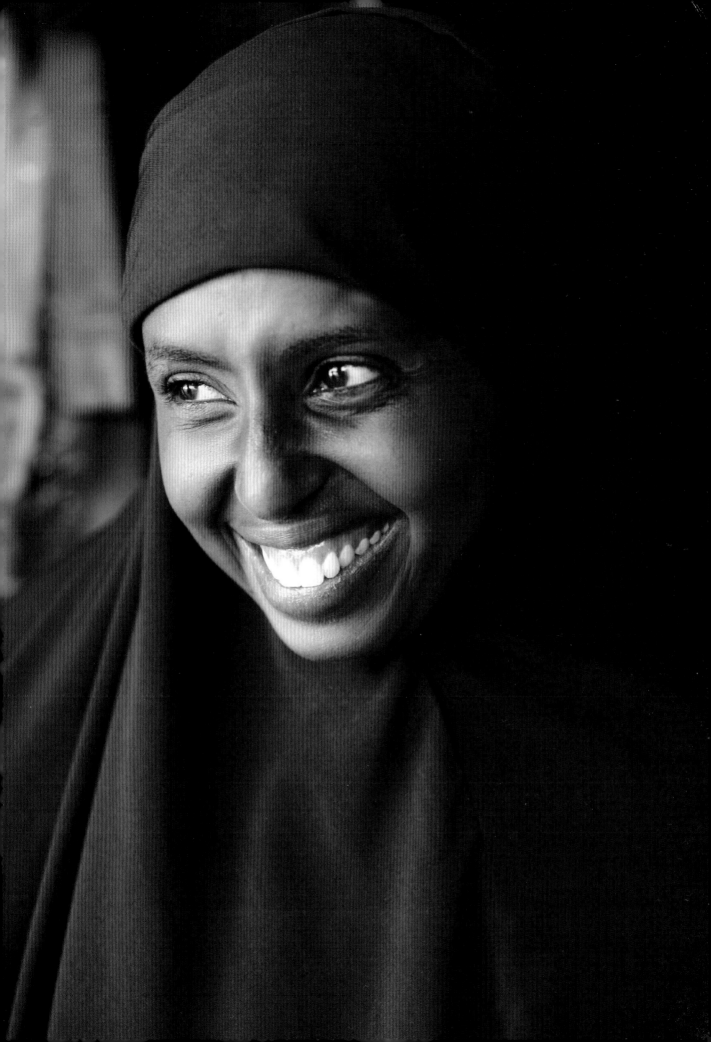

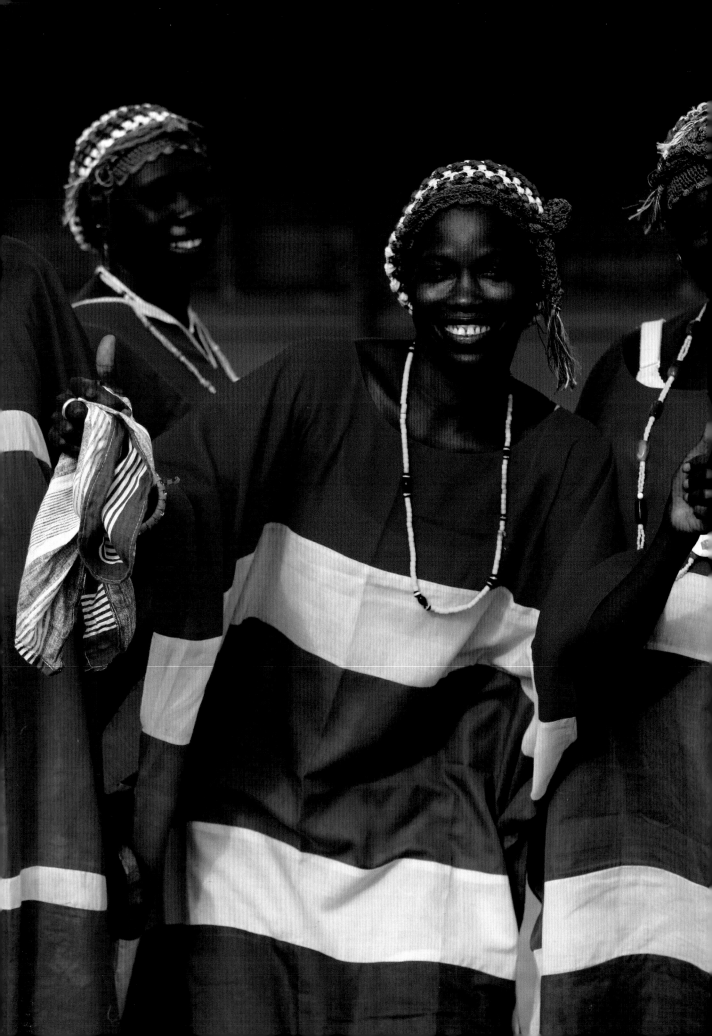

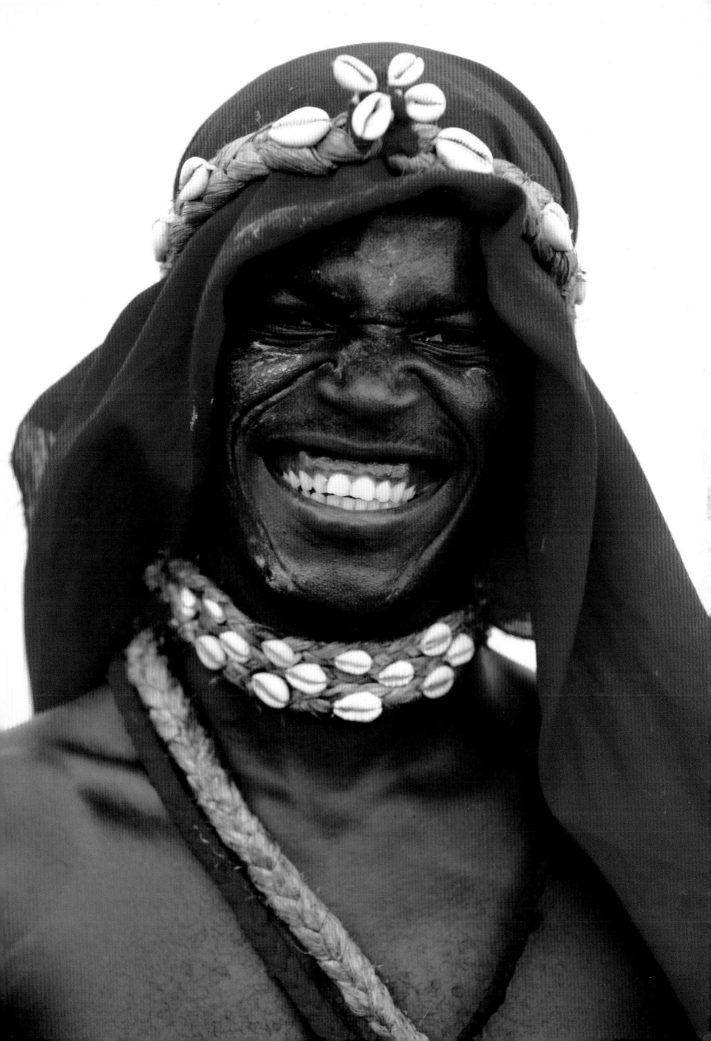

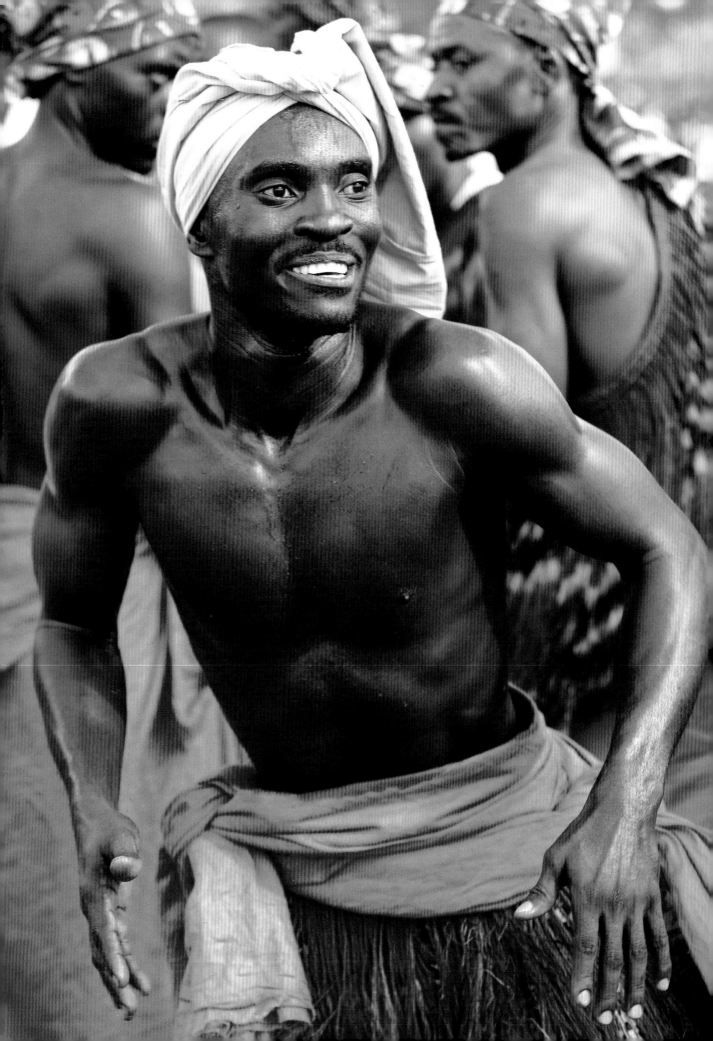

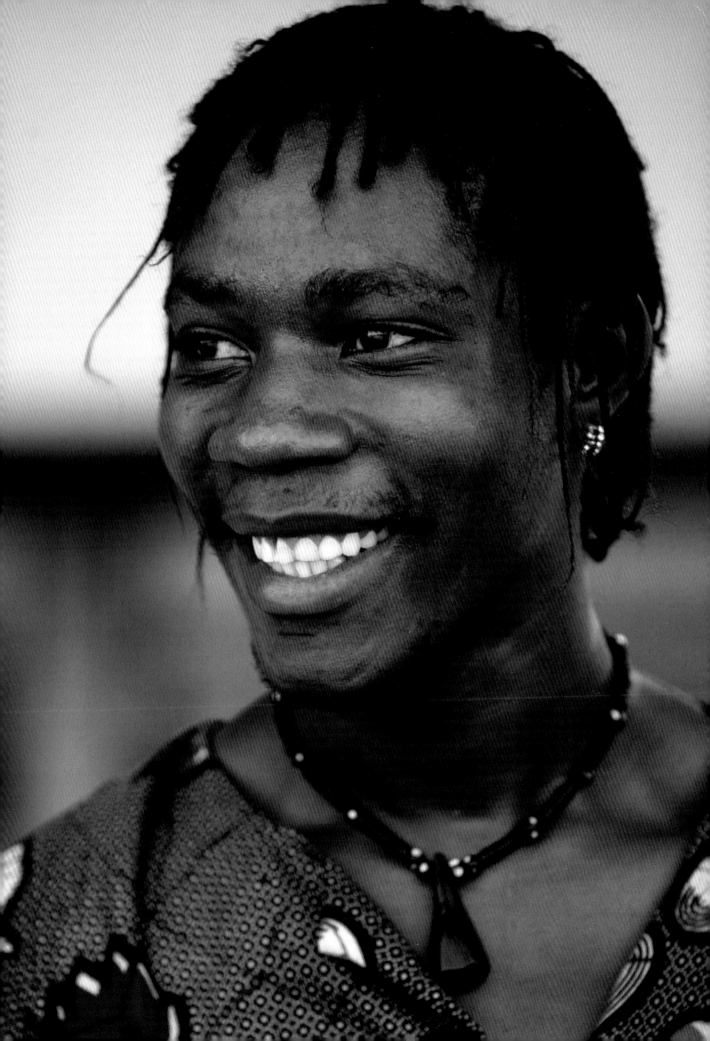

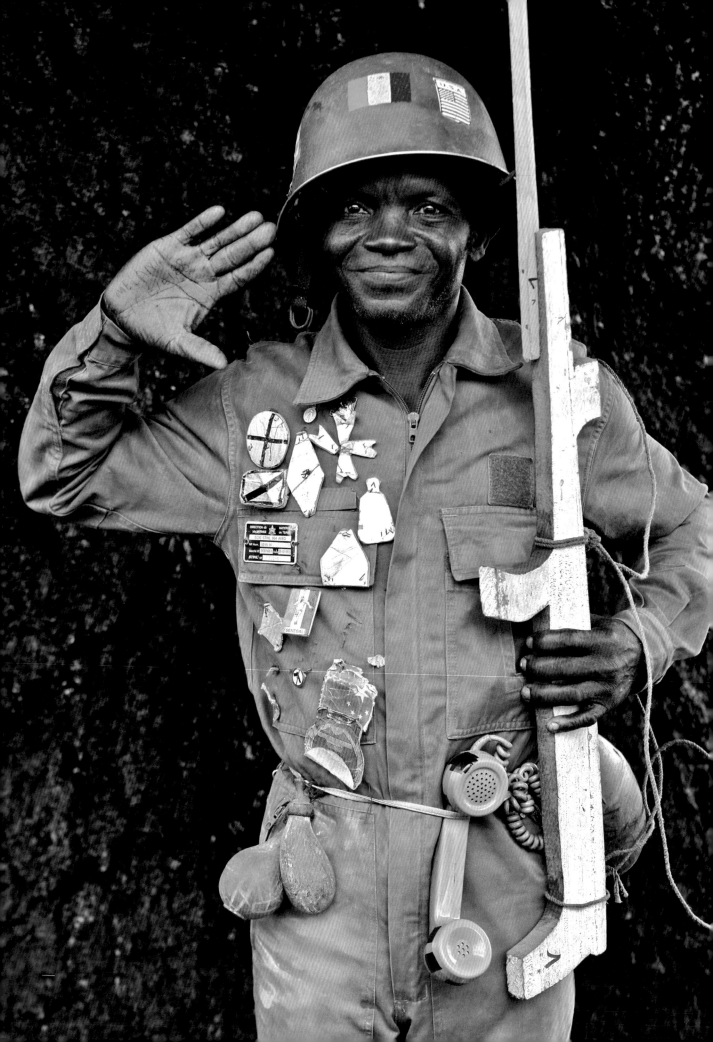

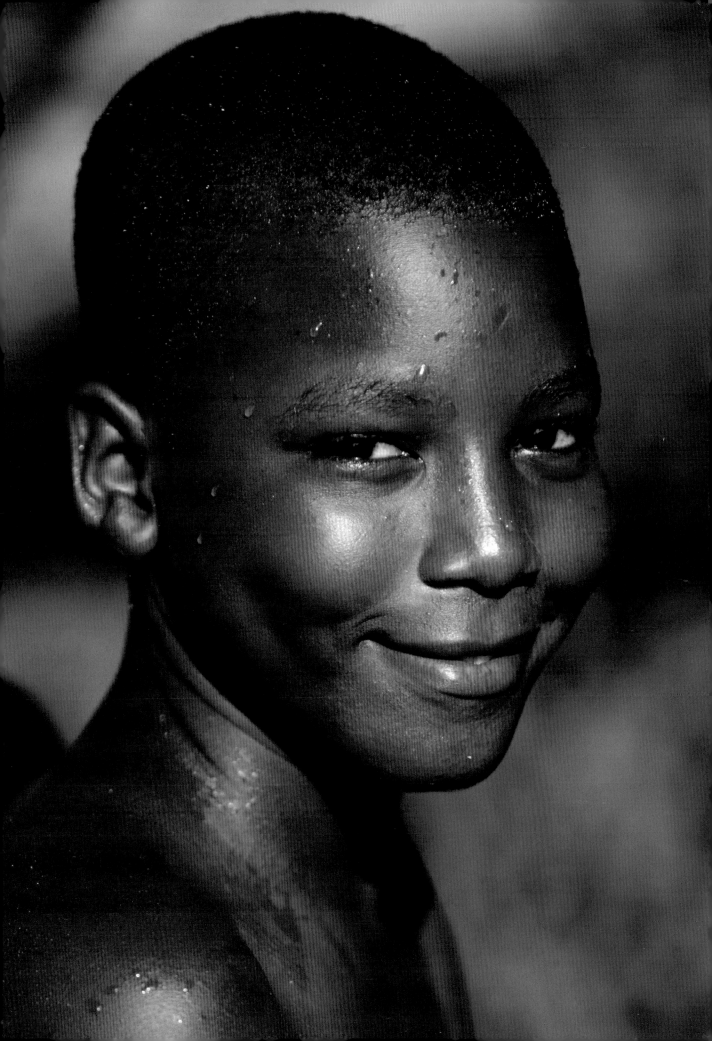

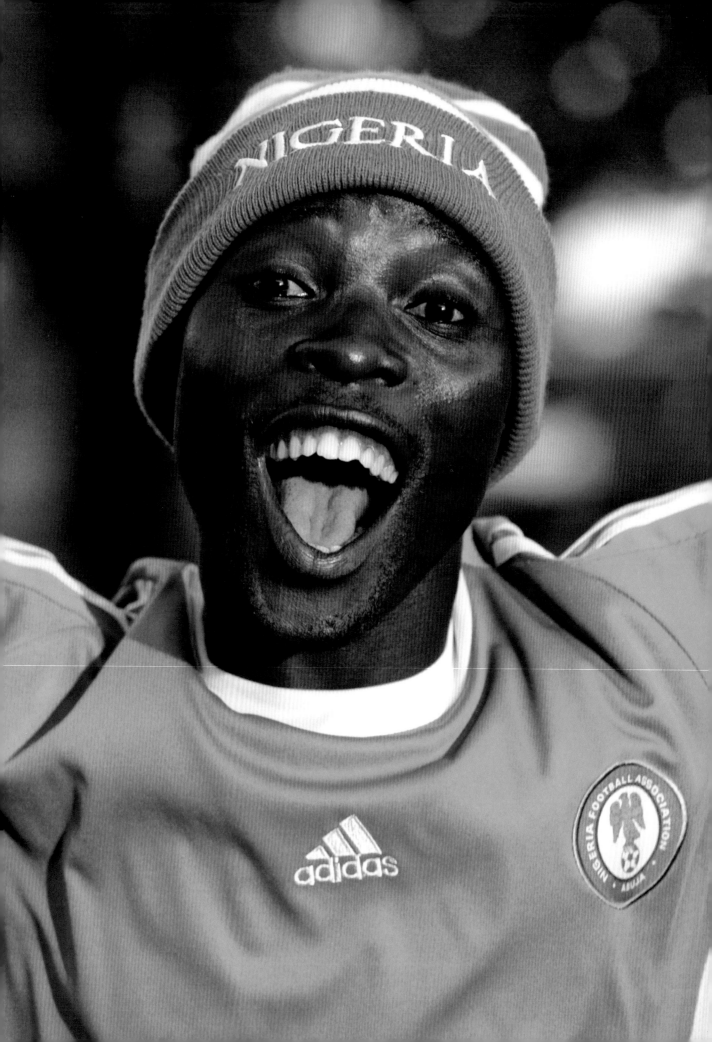

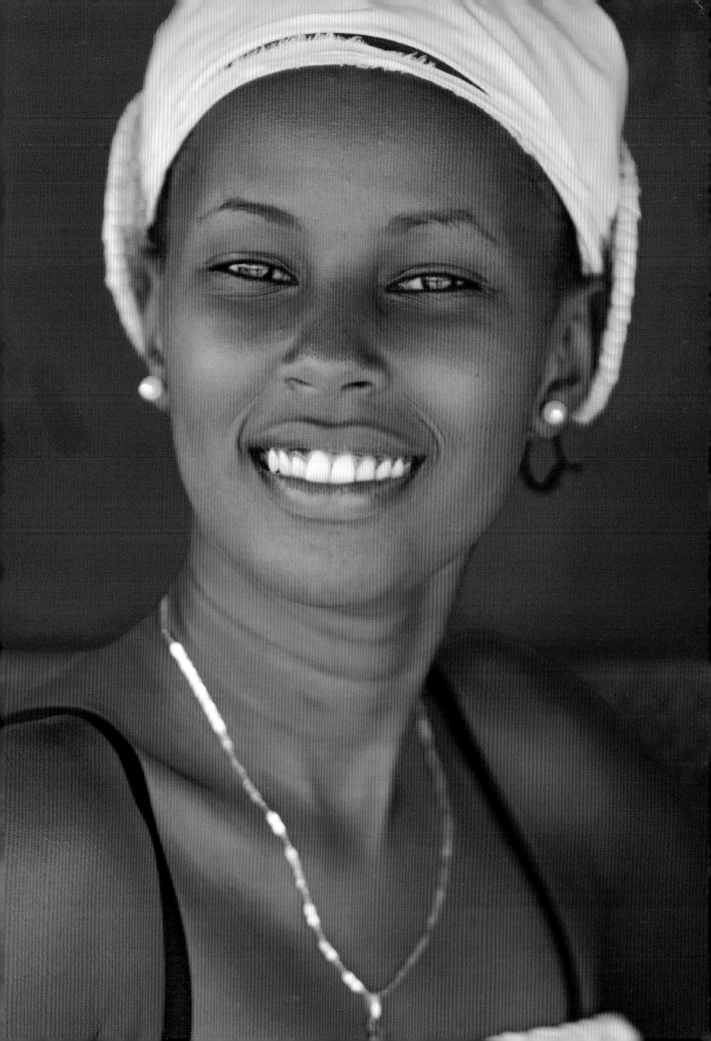

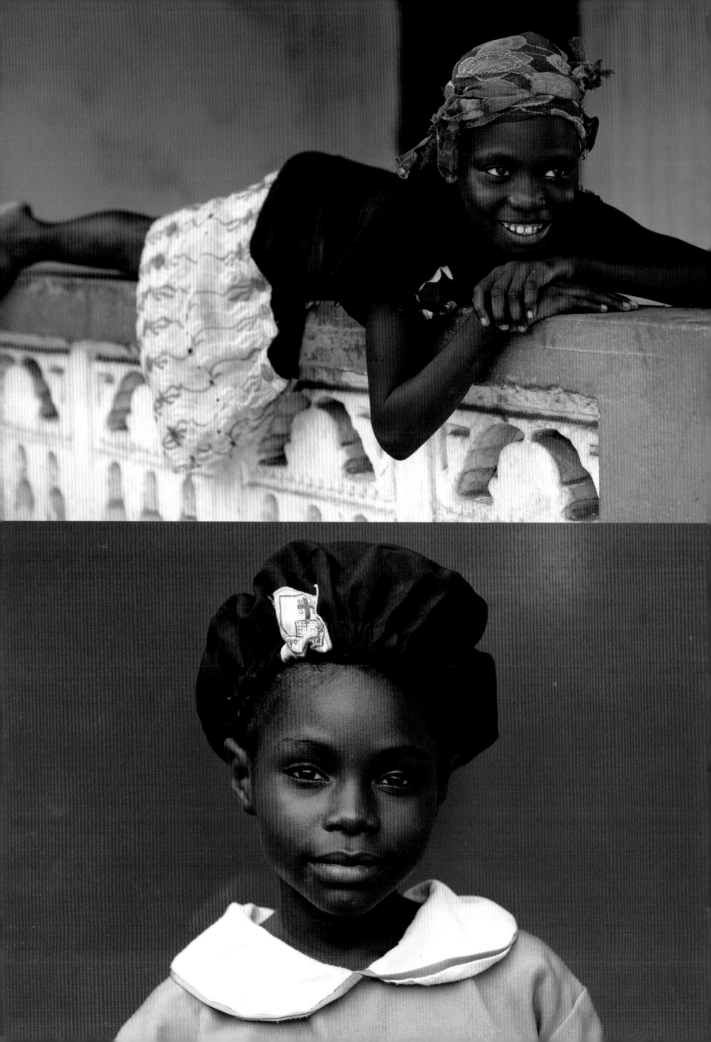

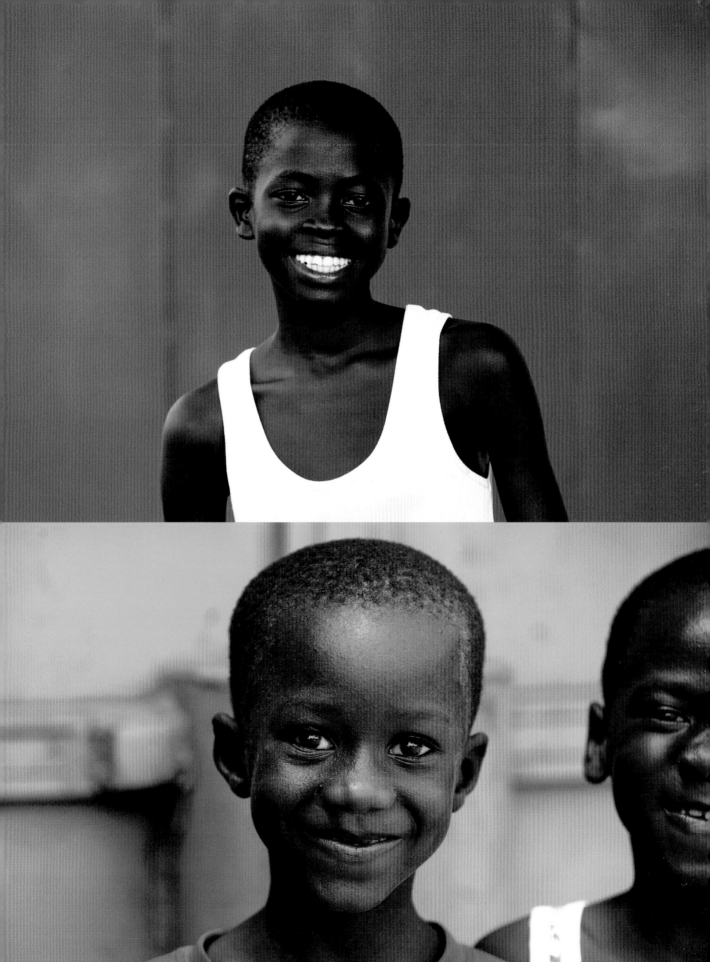

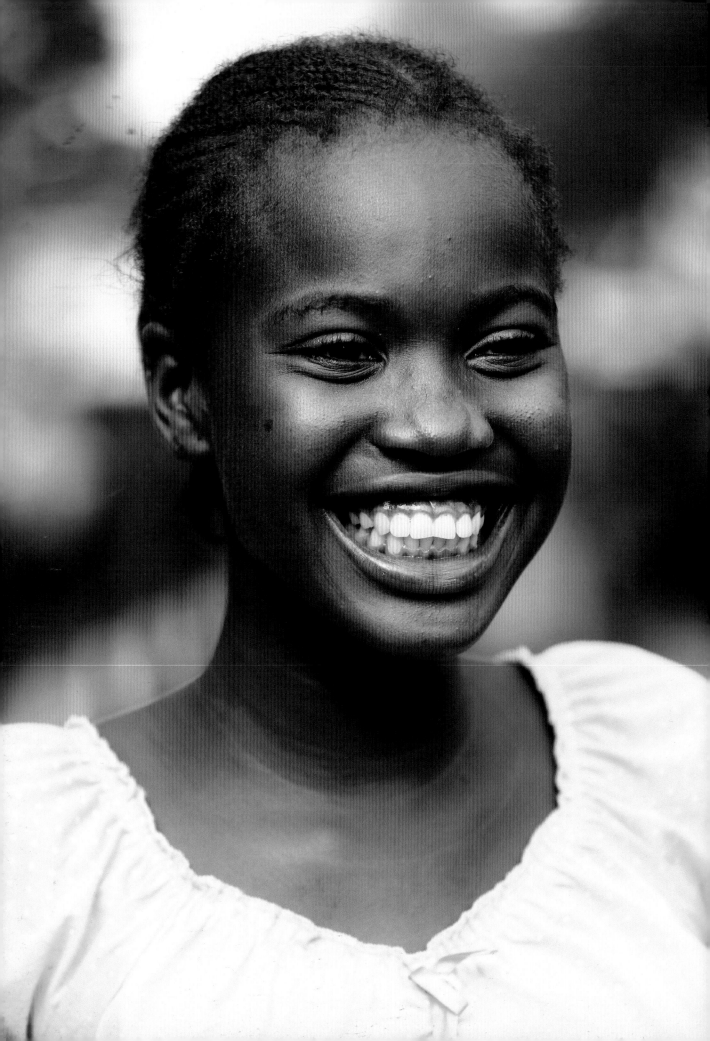

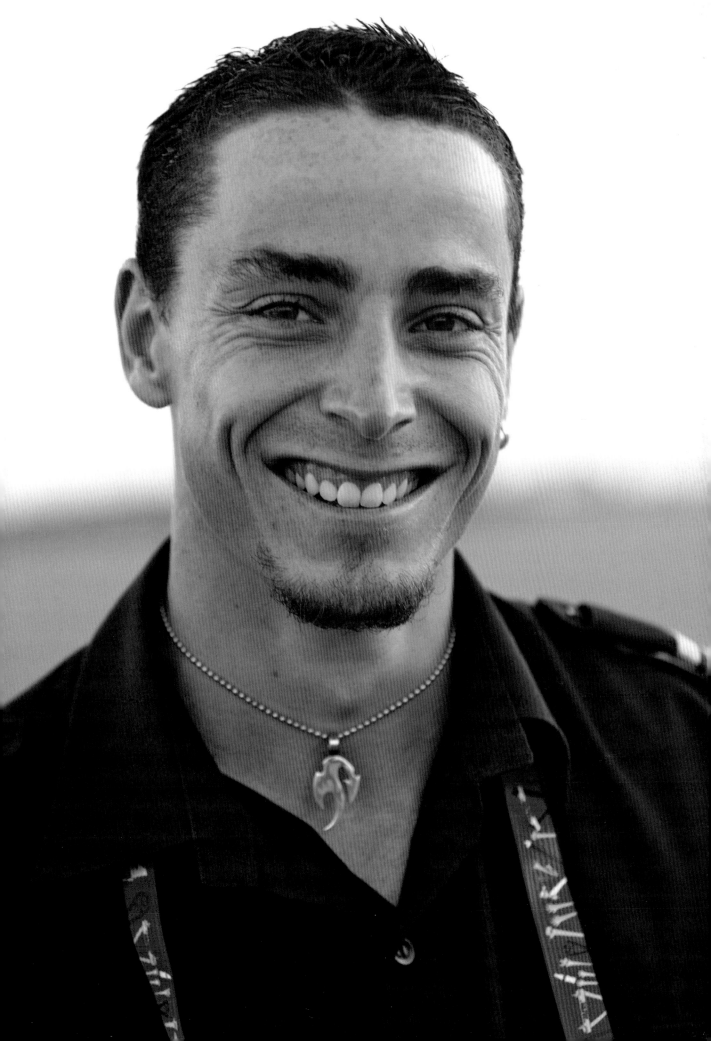

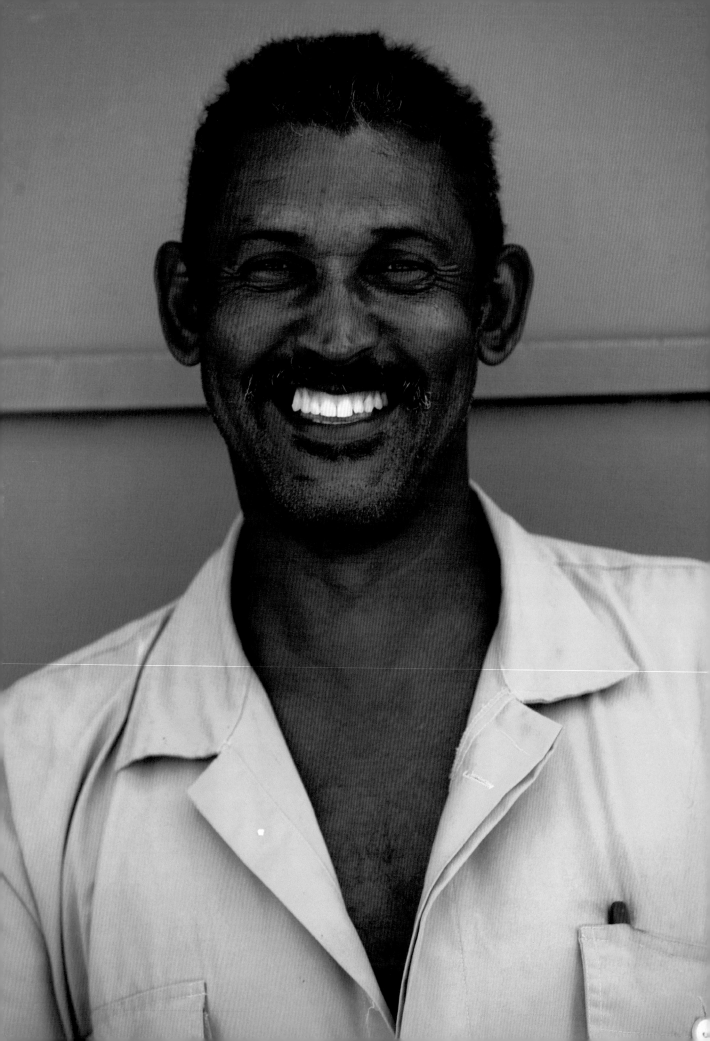

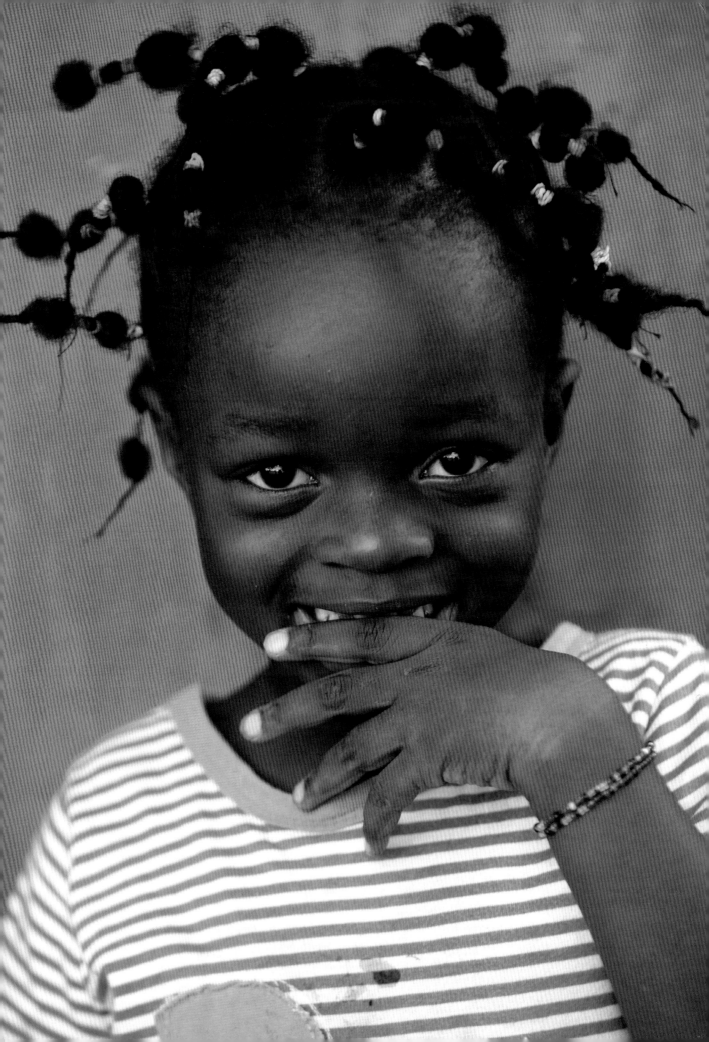

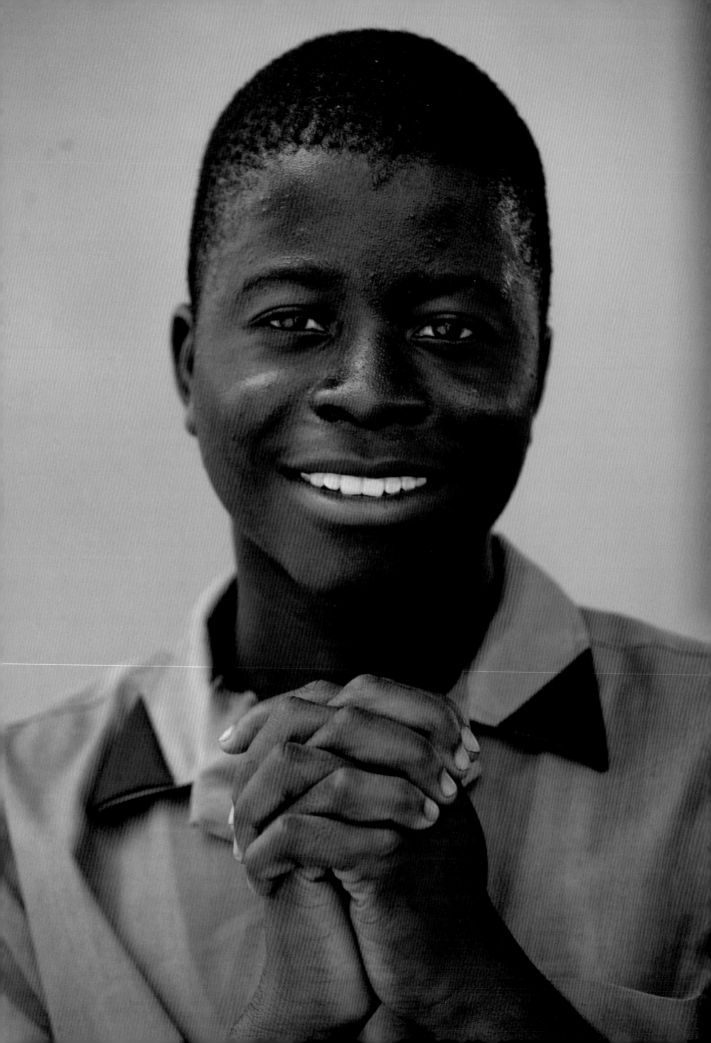

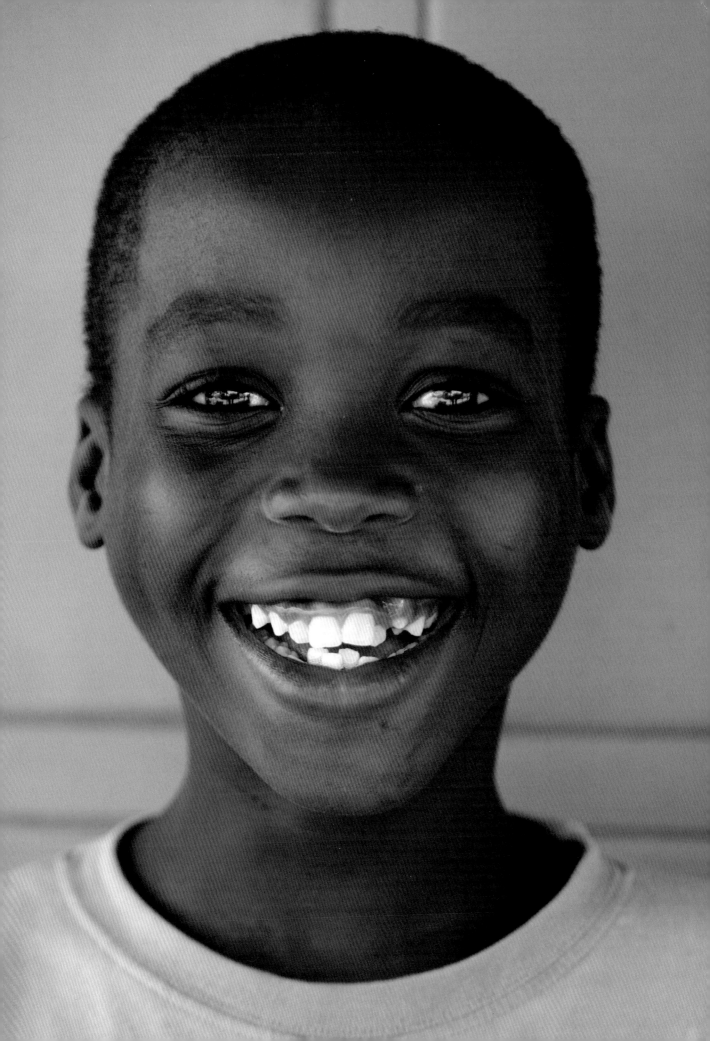

It radiates like the sun from within

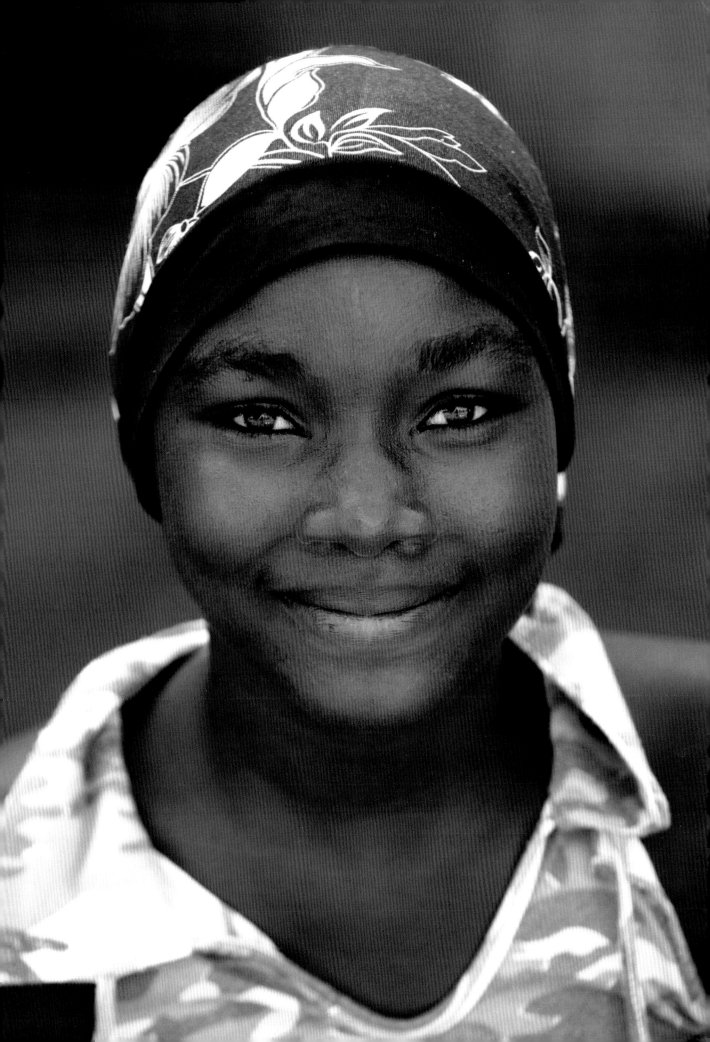

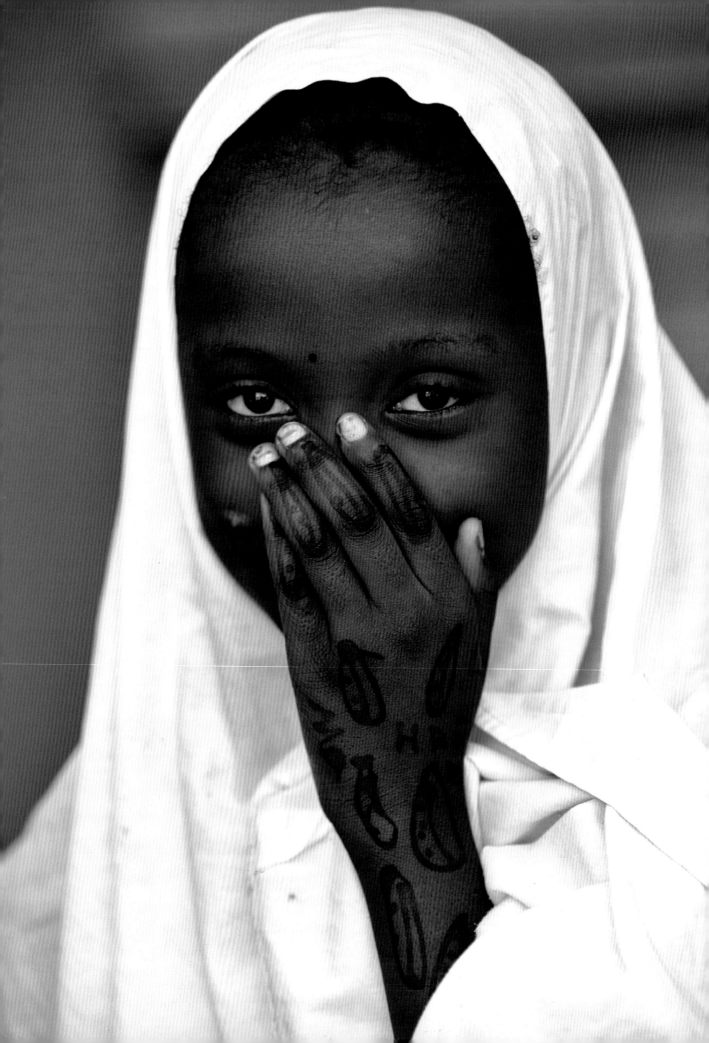

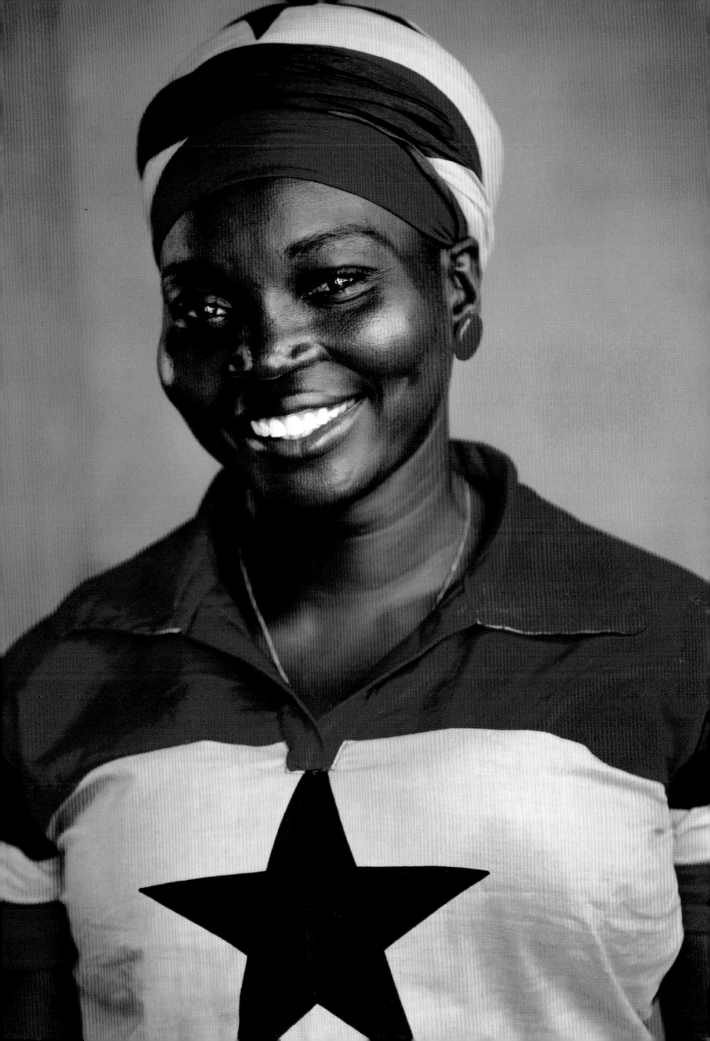

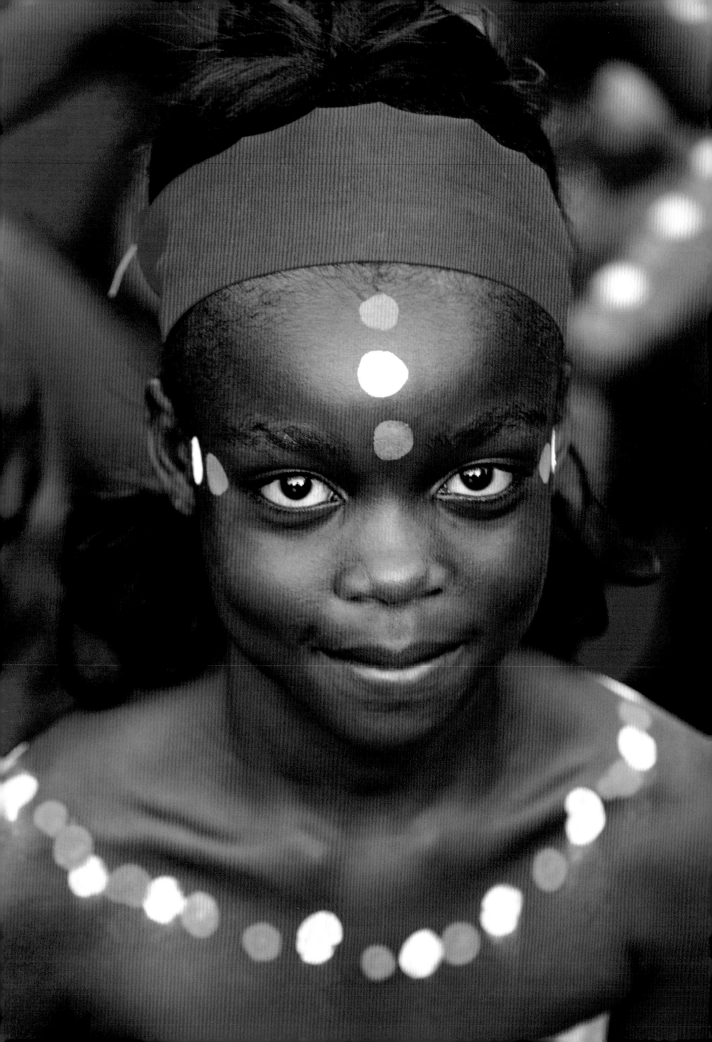

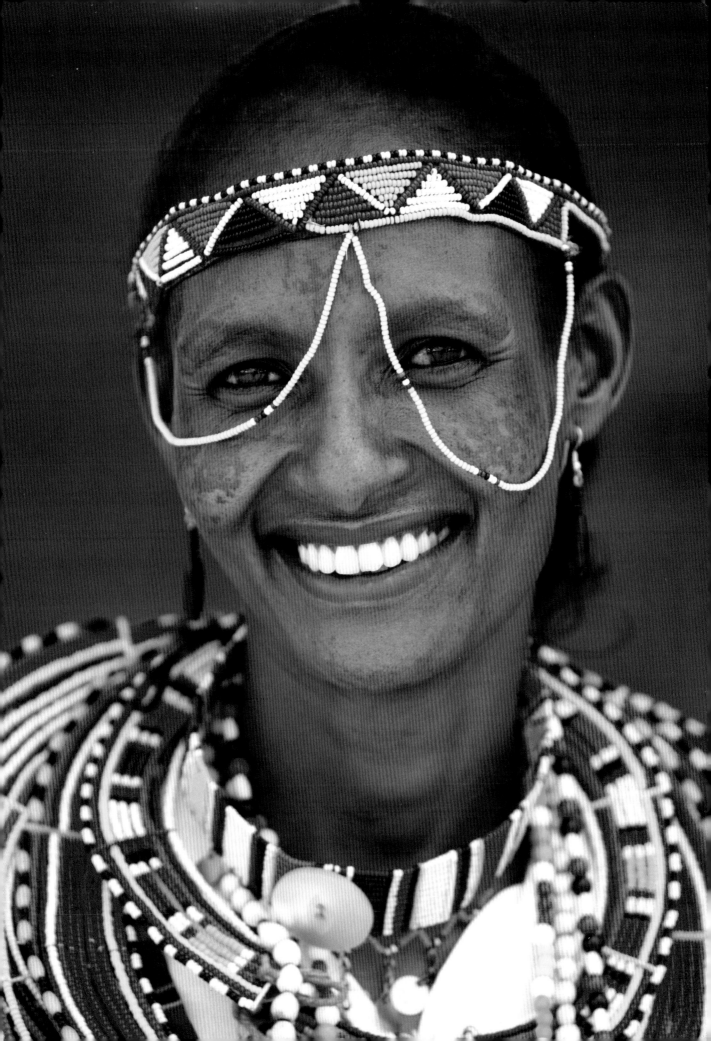

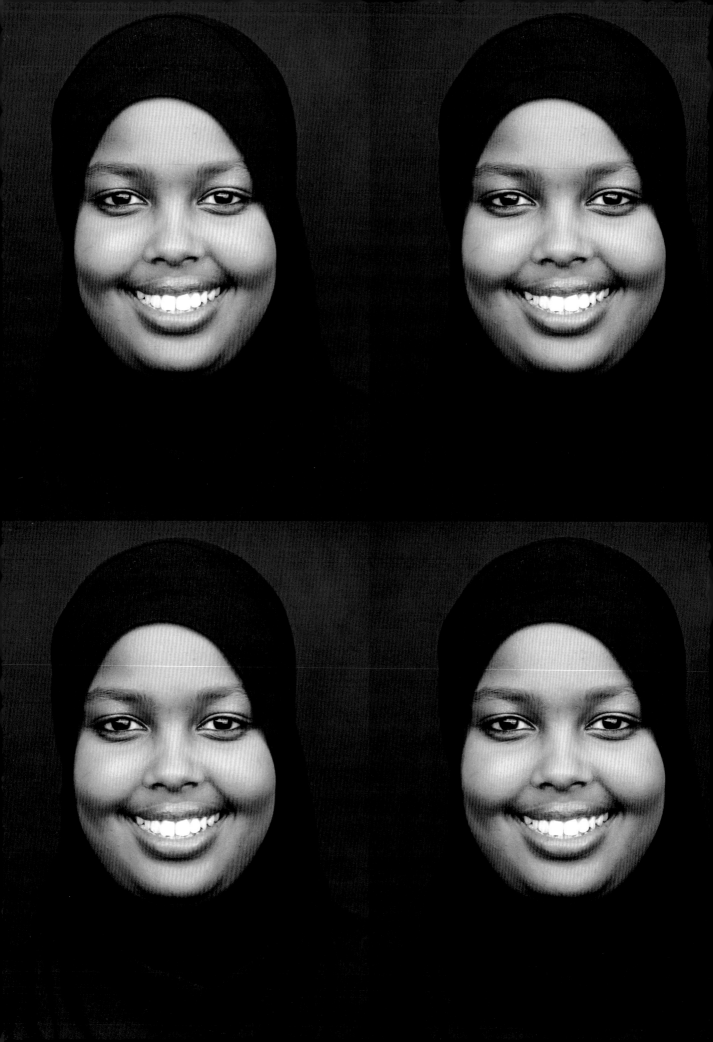

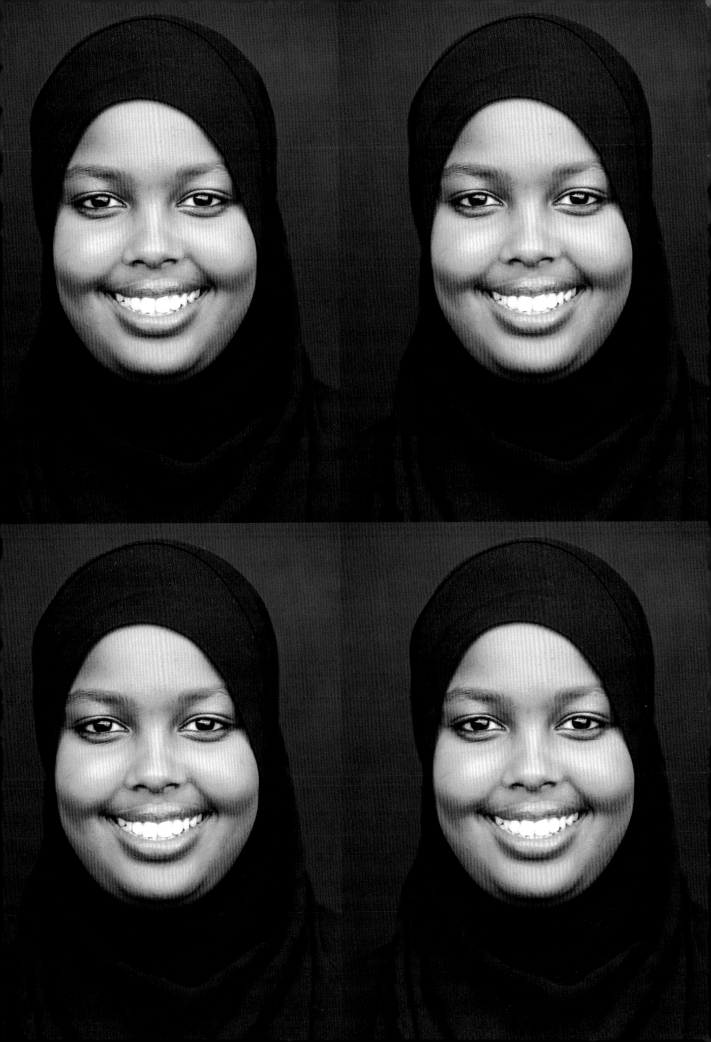

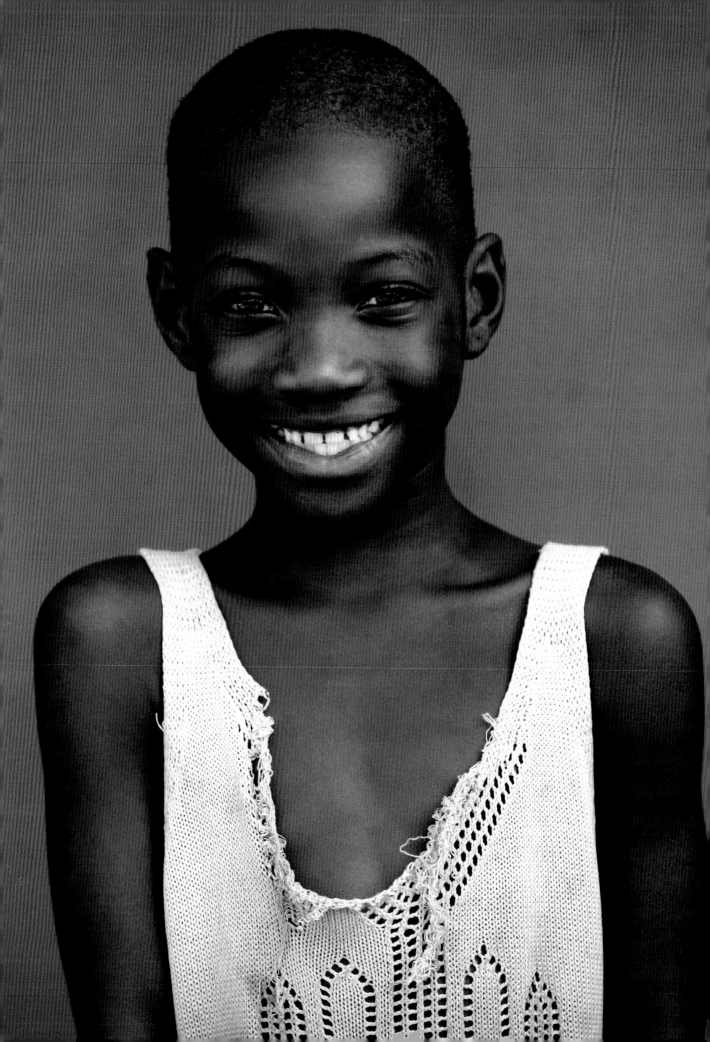

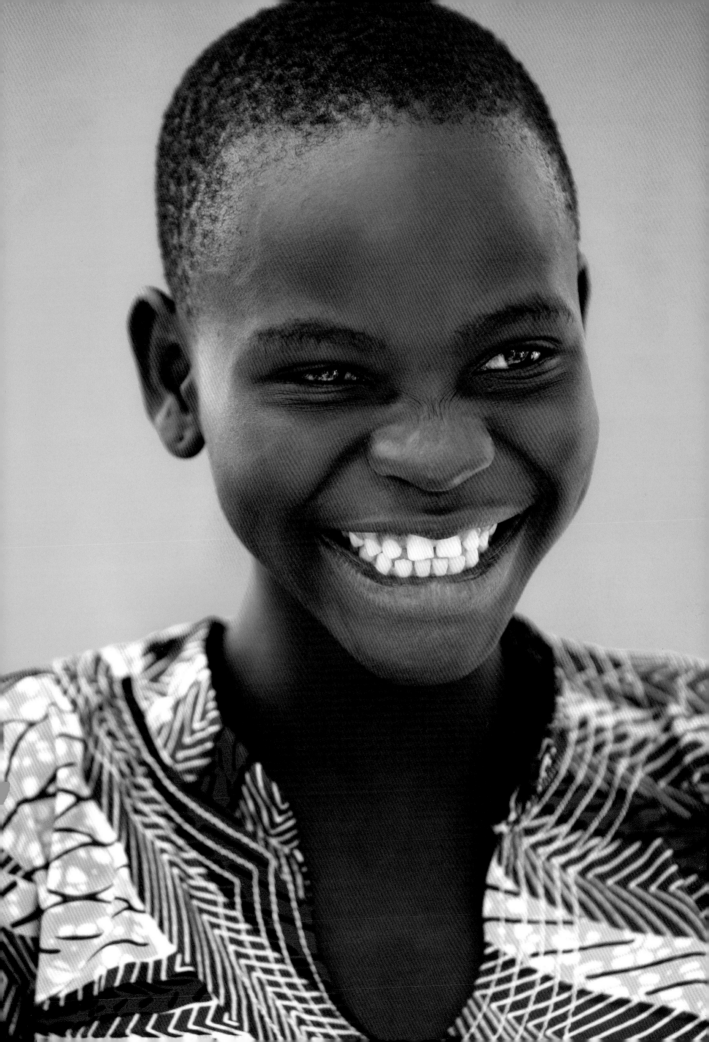

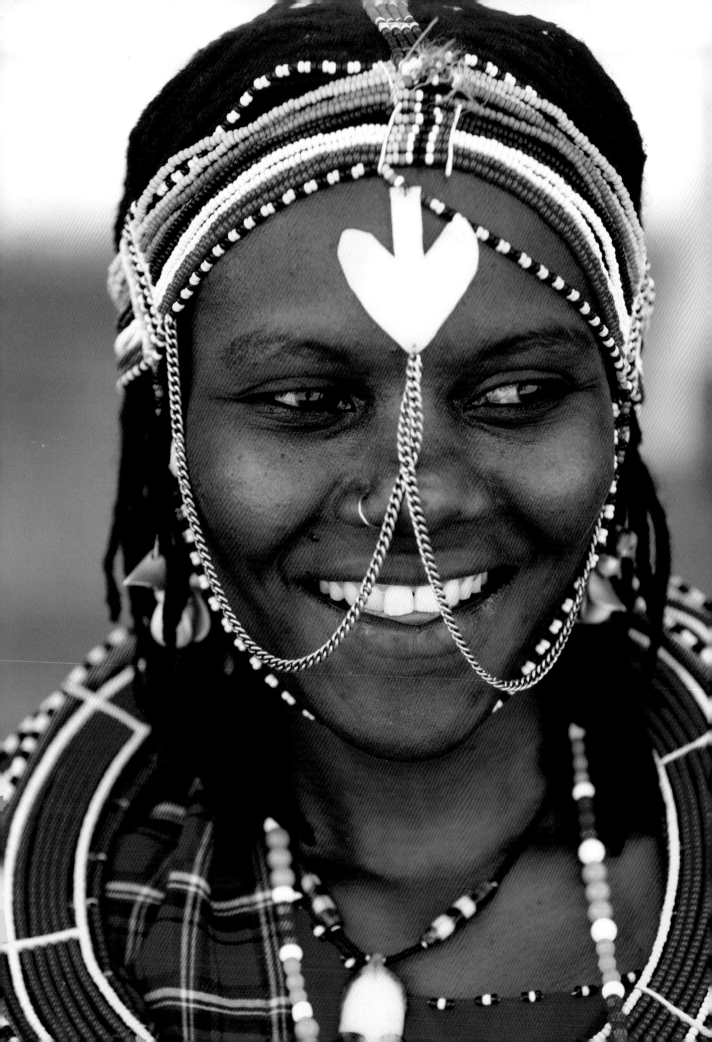

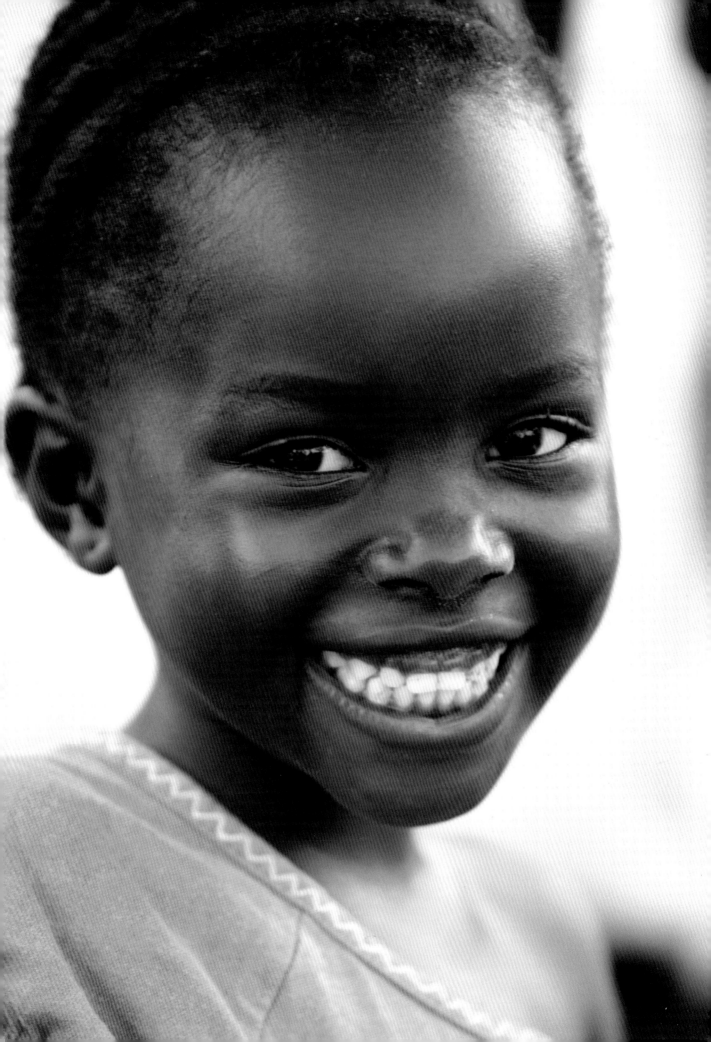

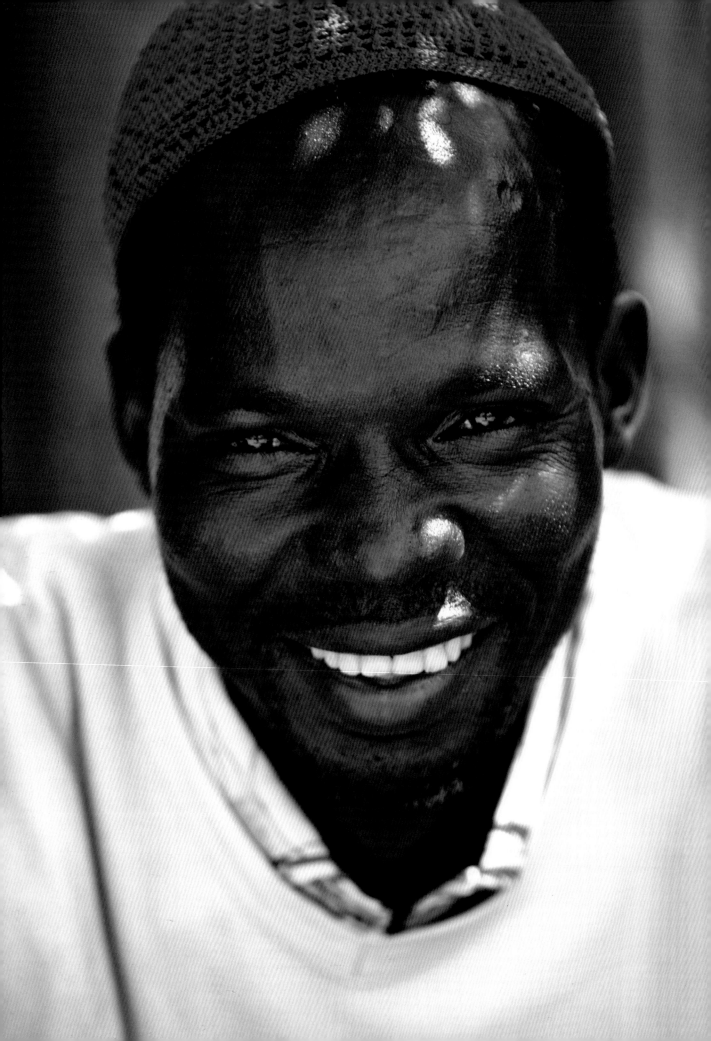

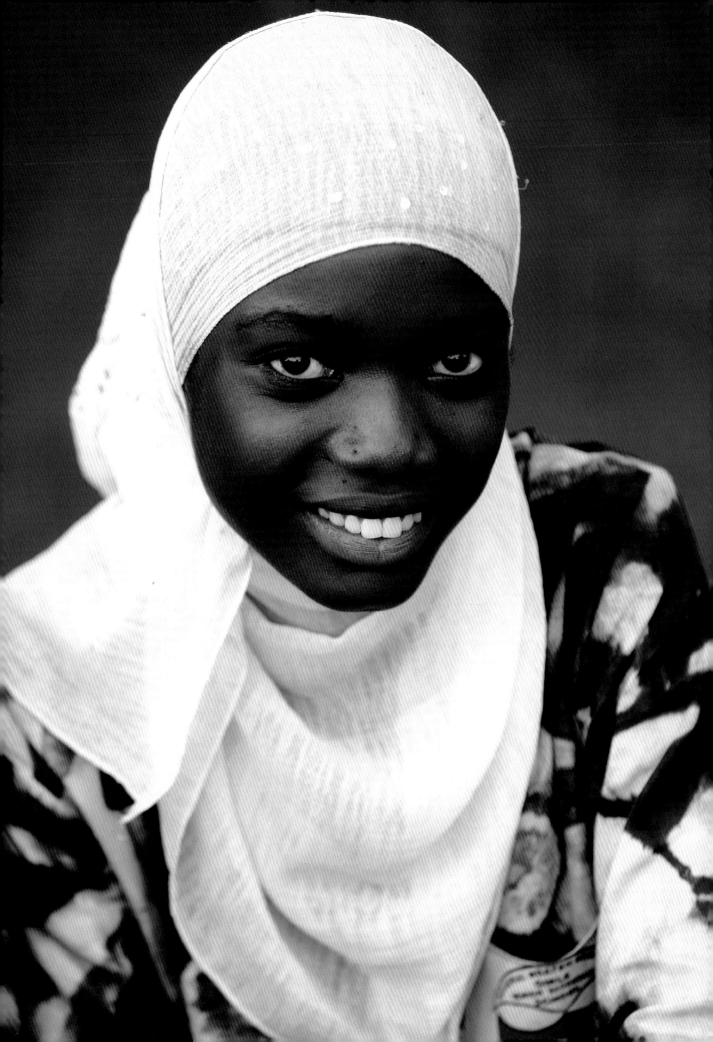

Happiness is contagious

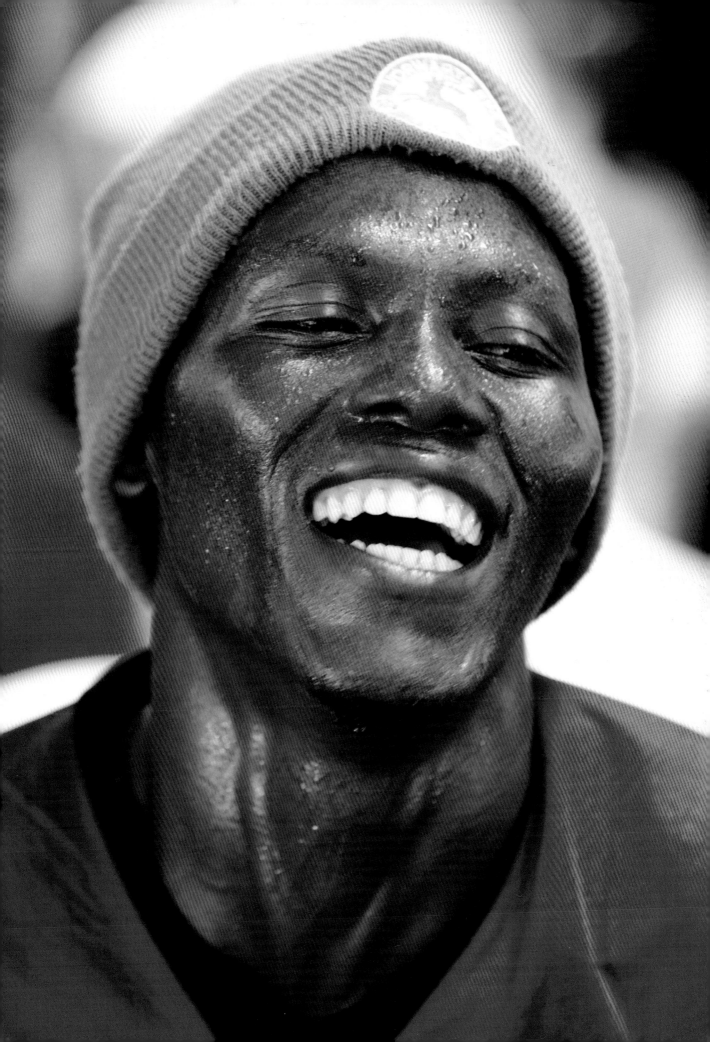

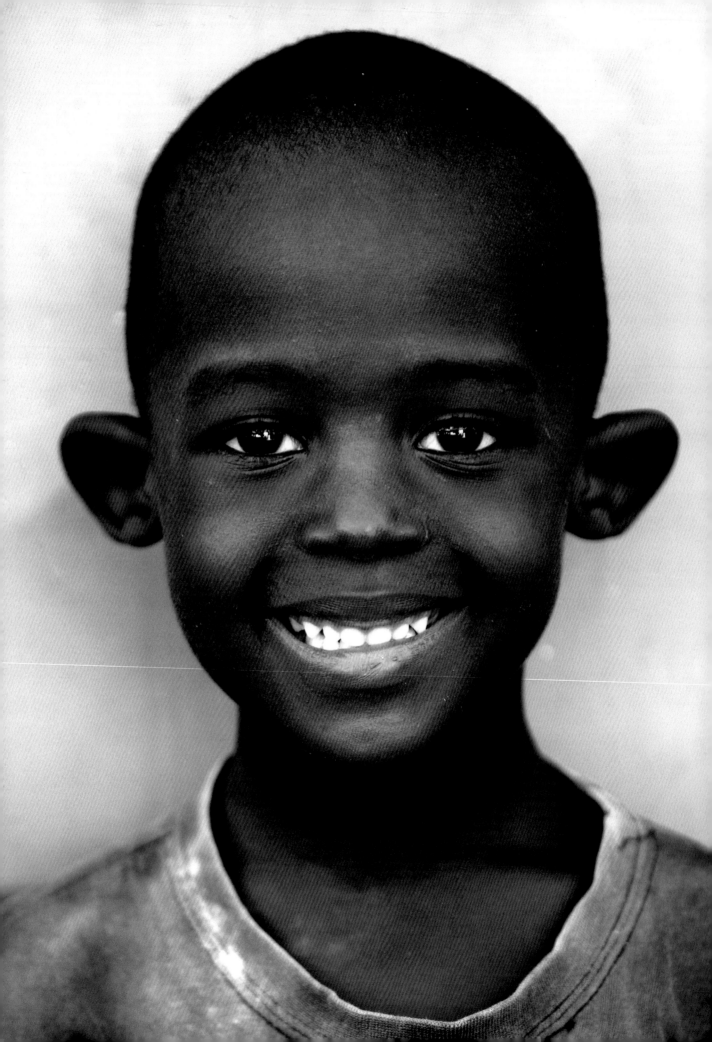

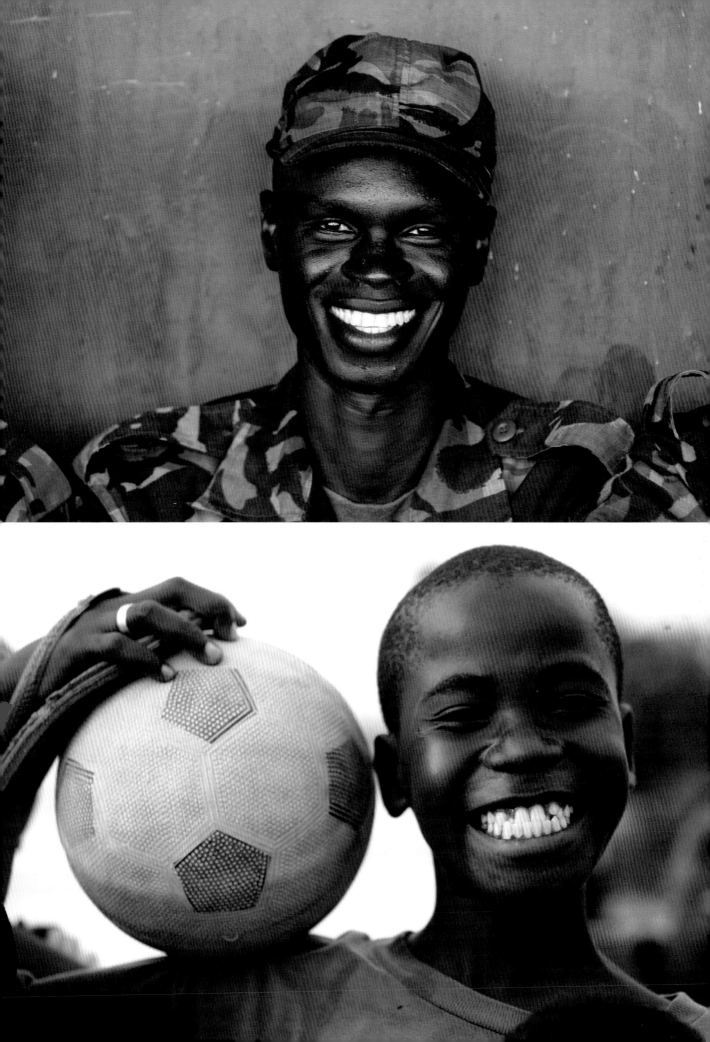

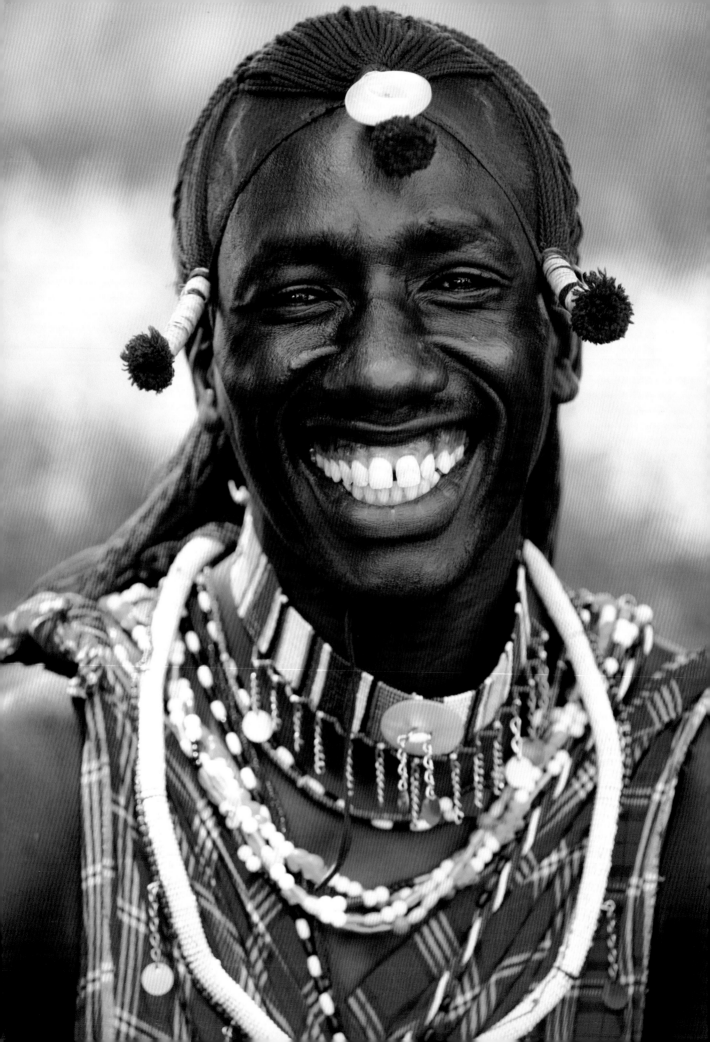

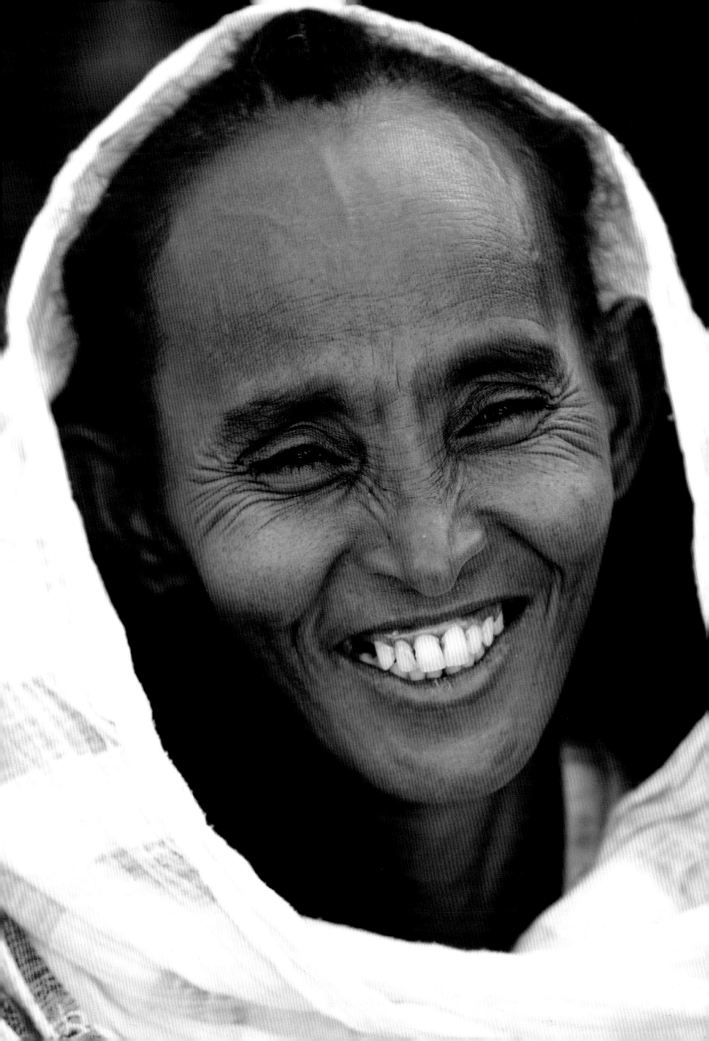

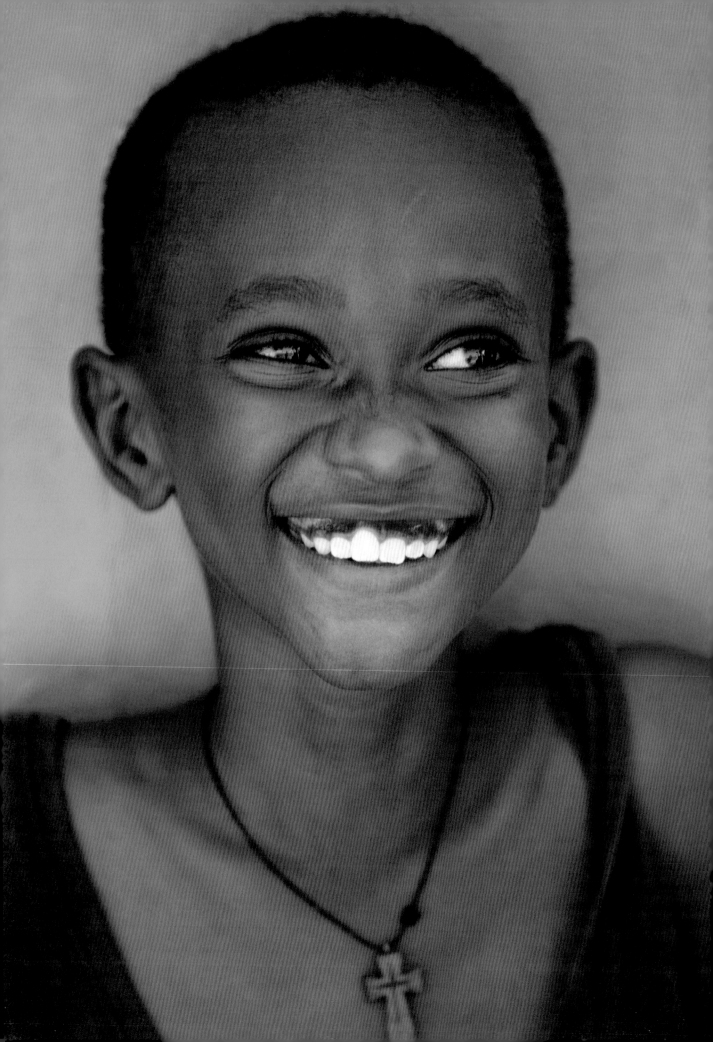

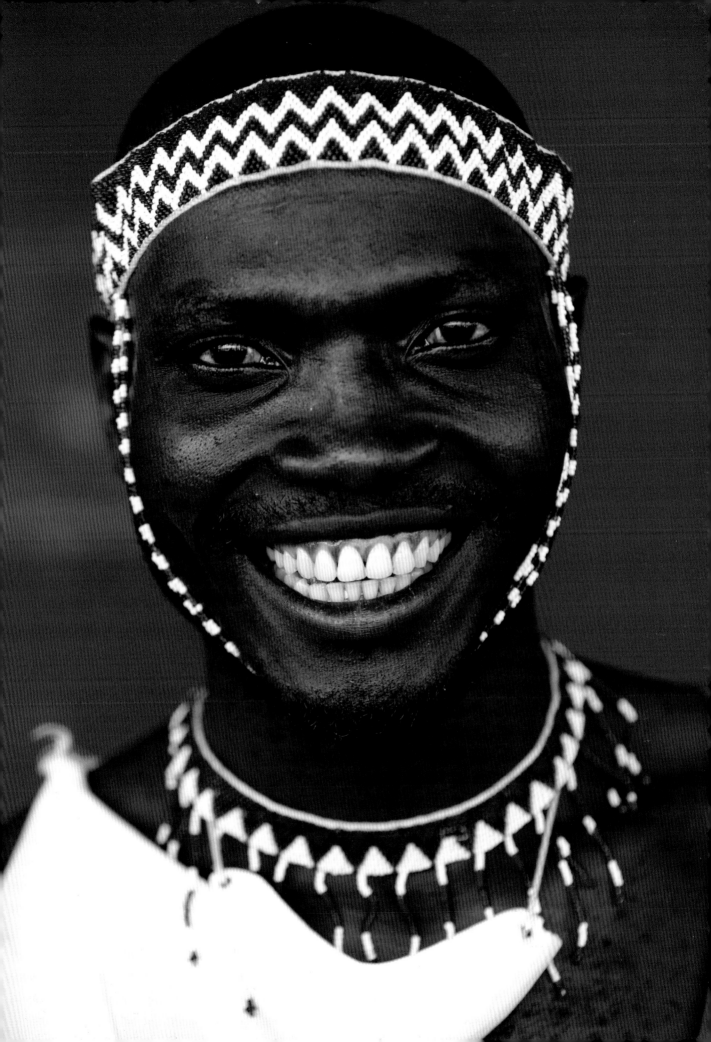

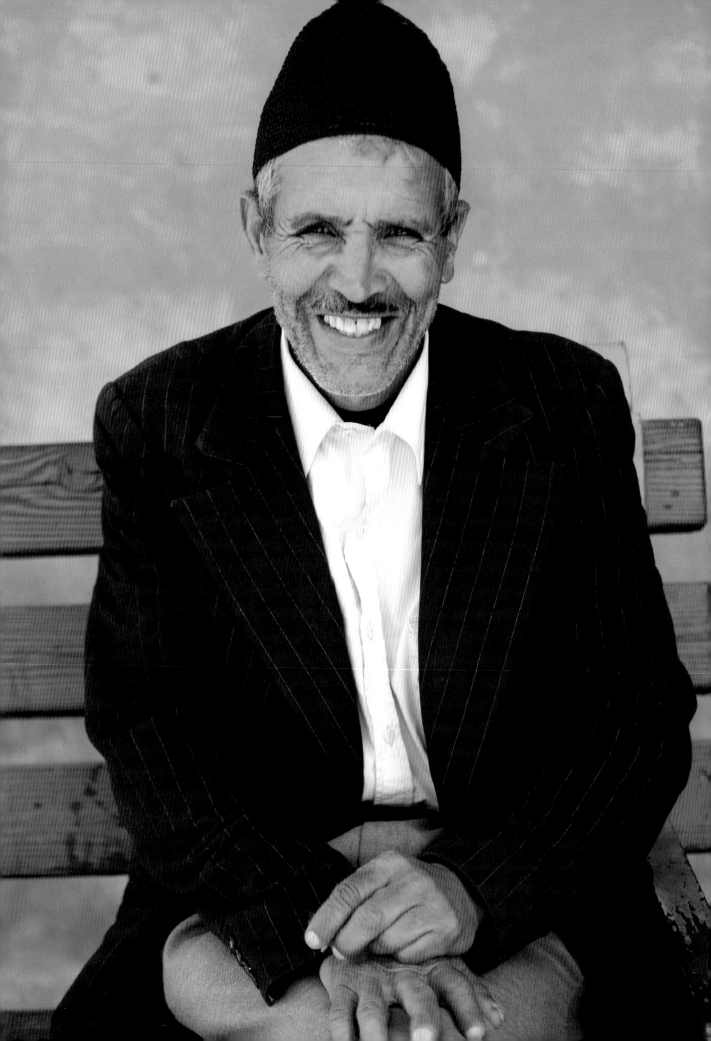

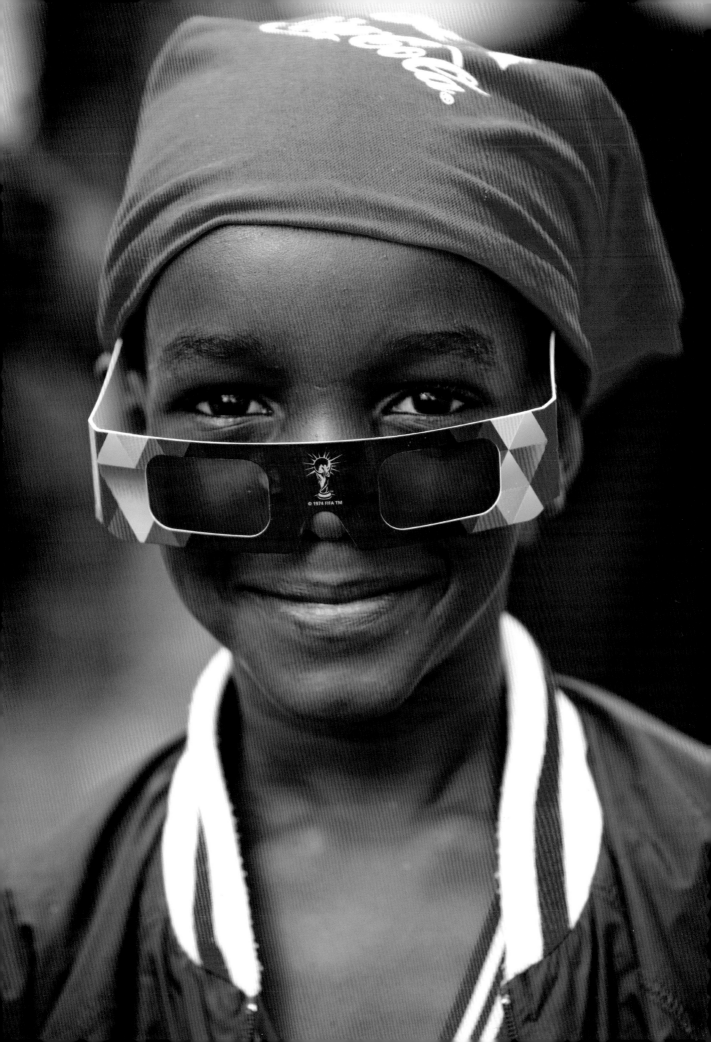

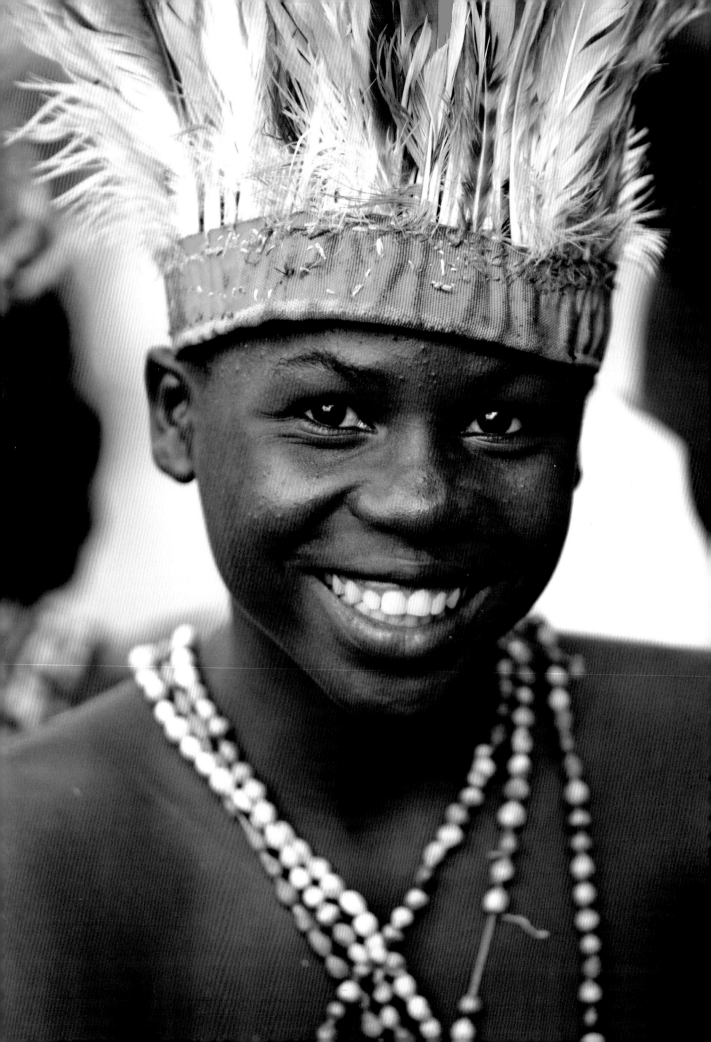

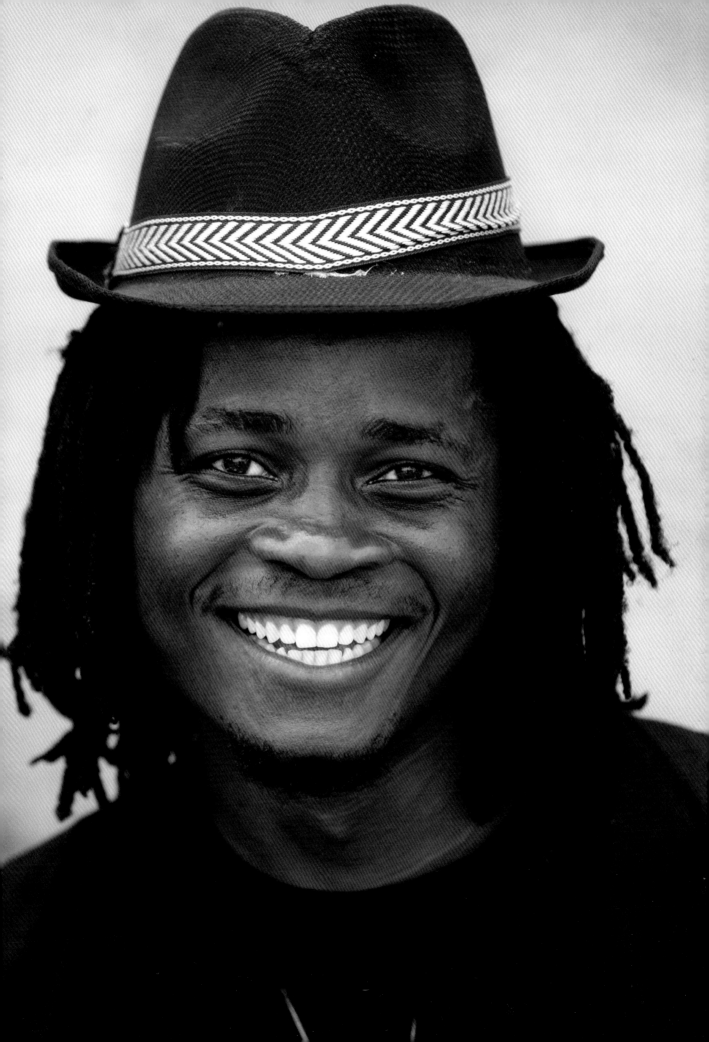

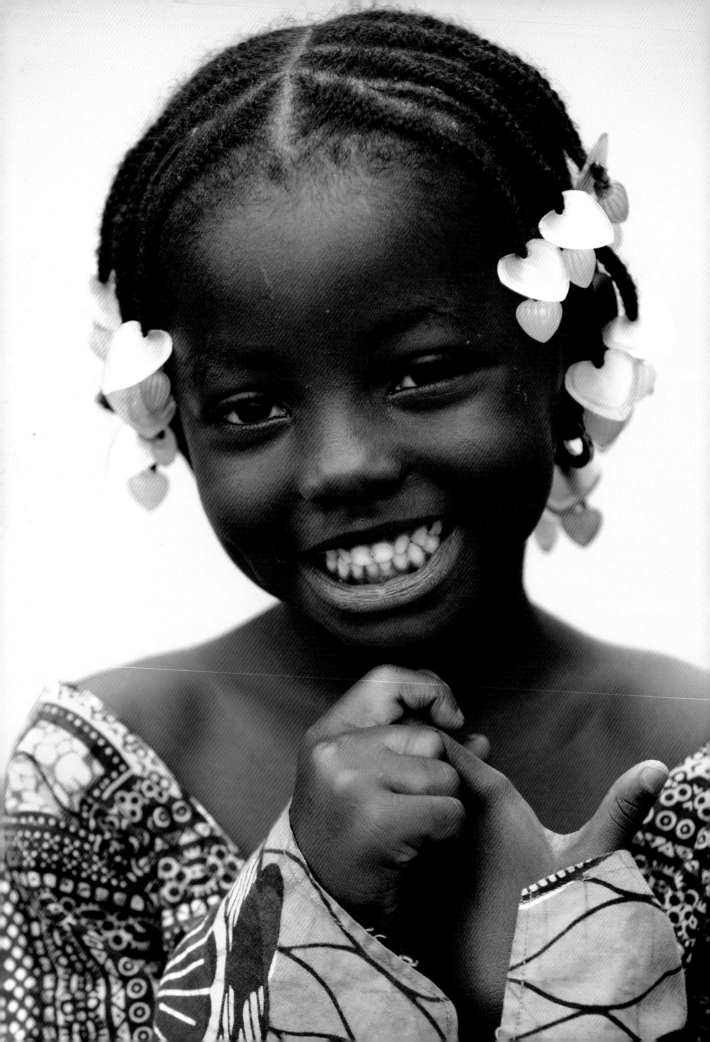

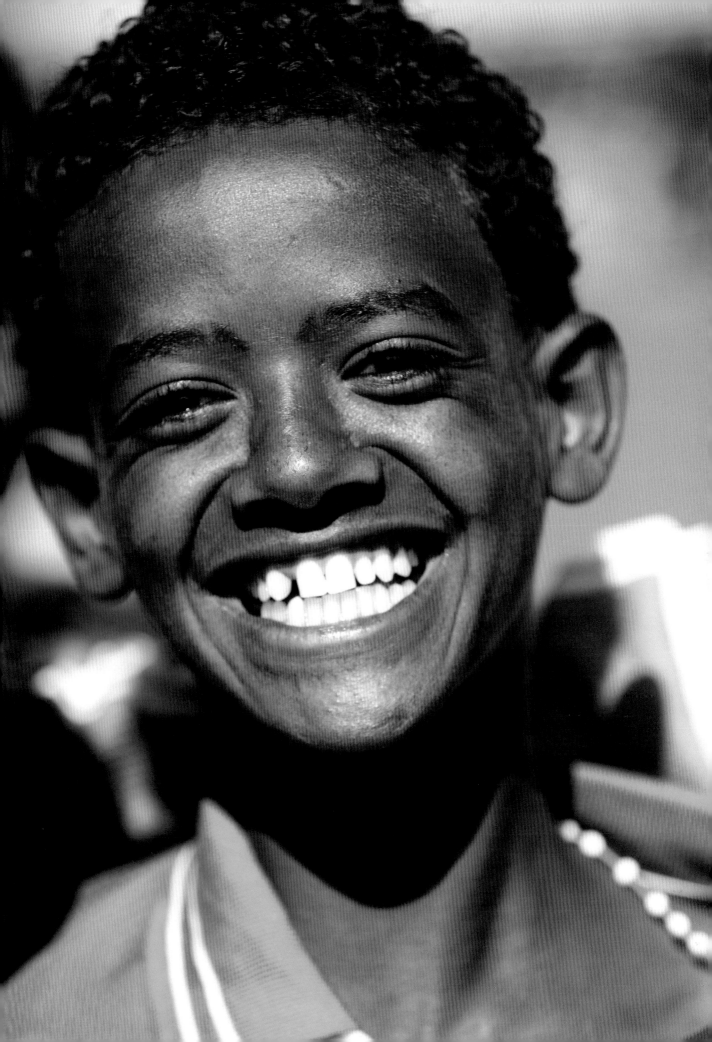

Happiness is rooted in optimism

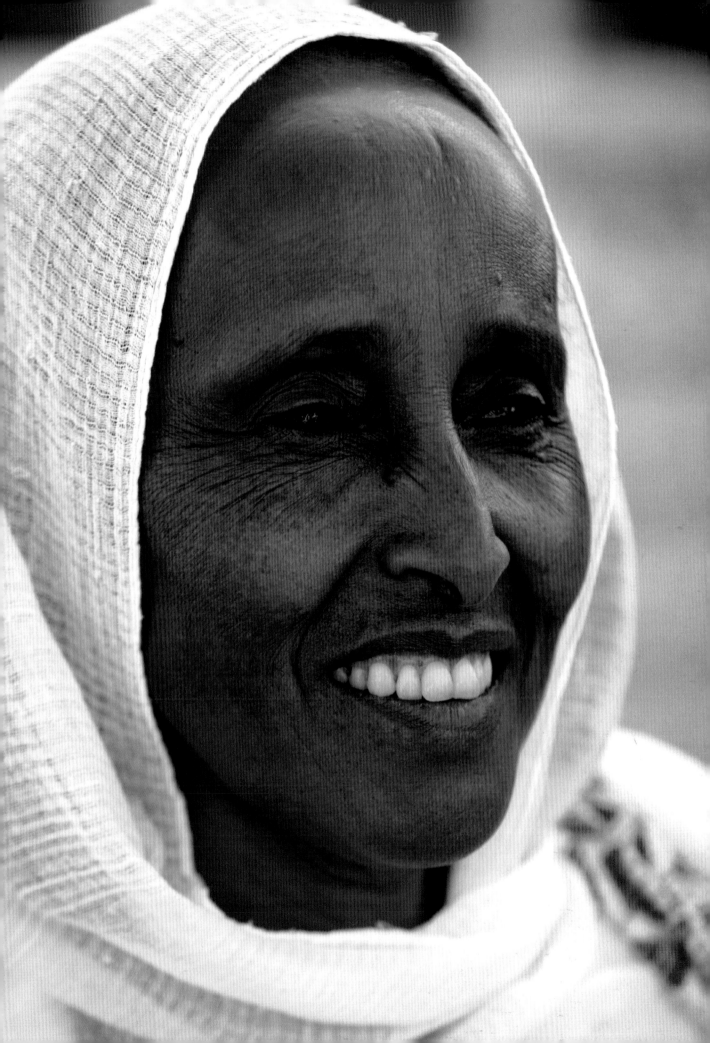

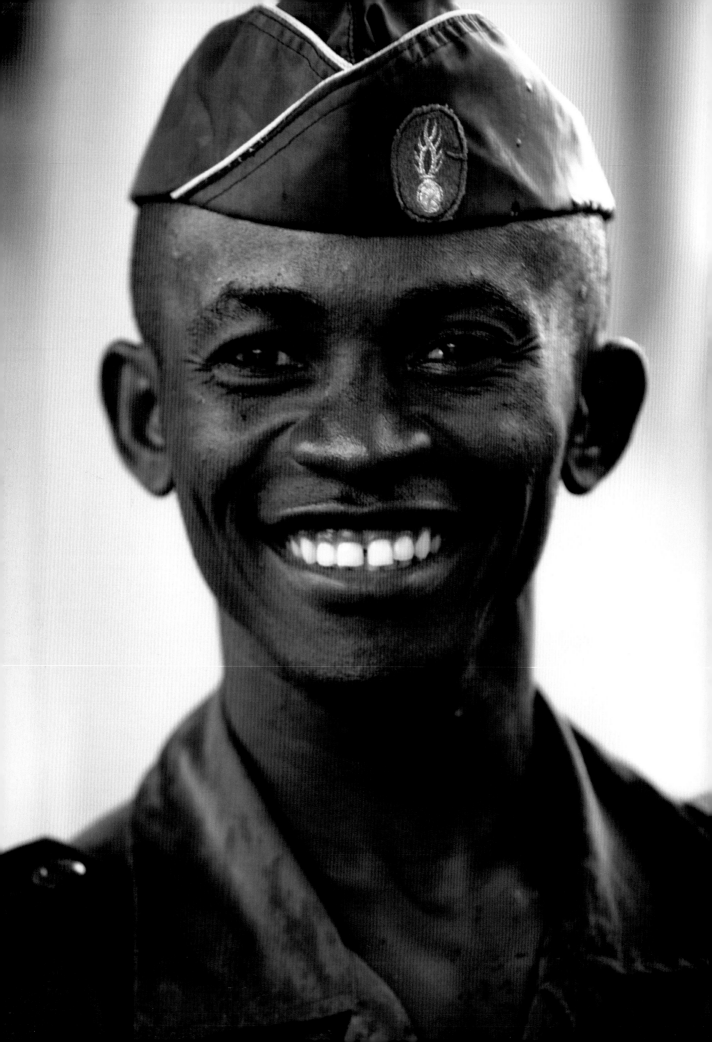

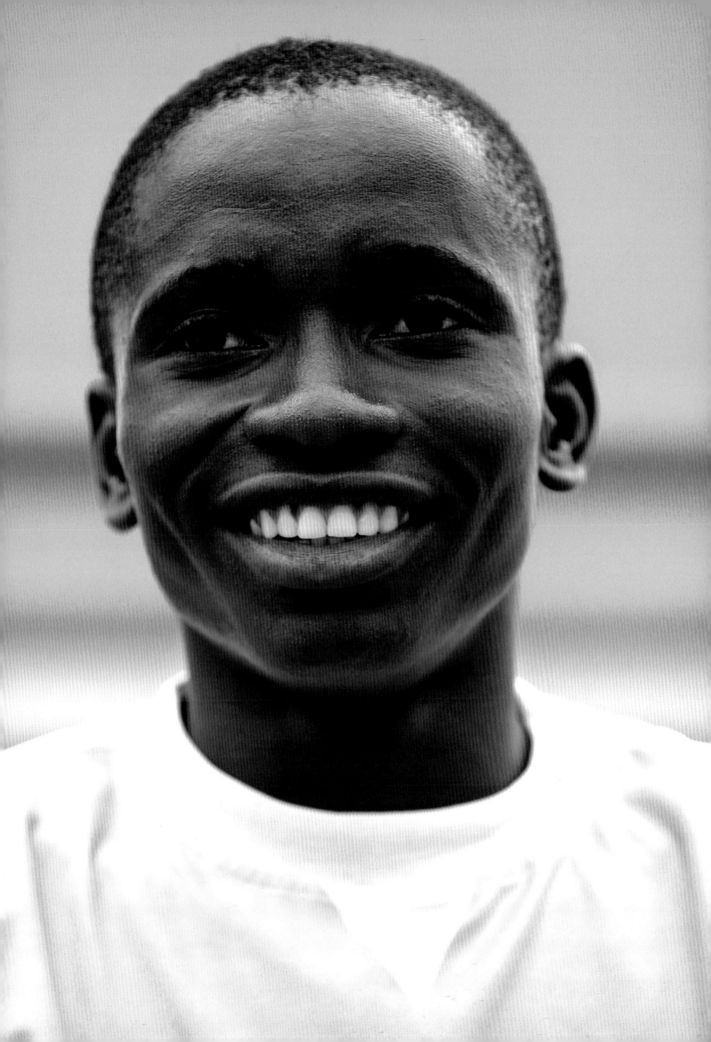

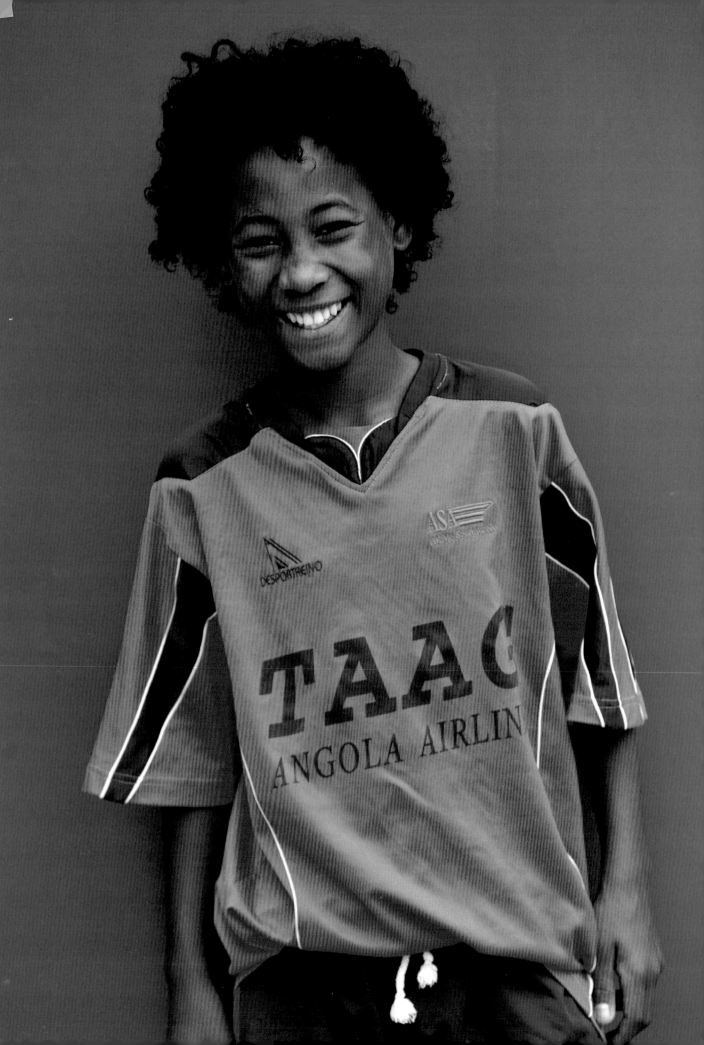

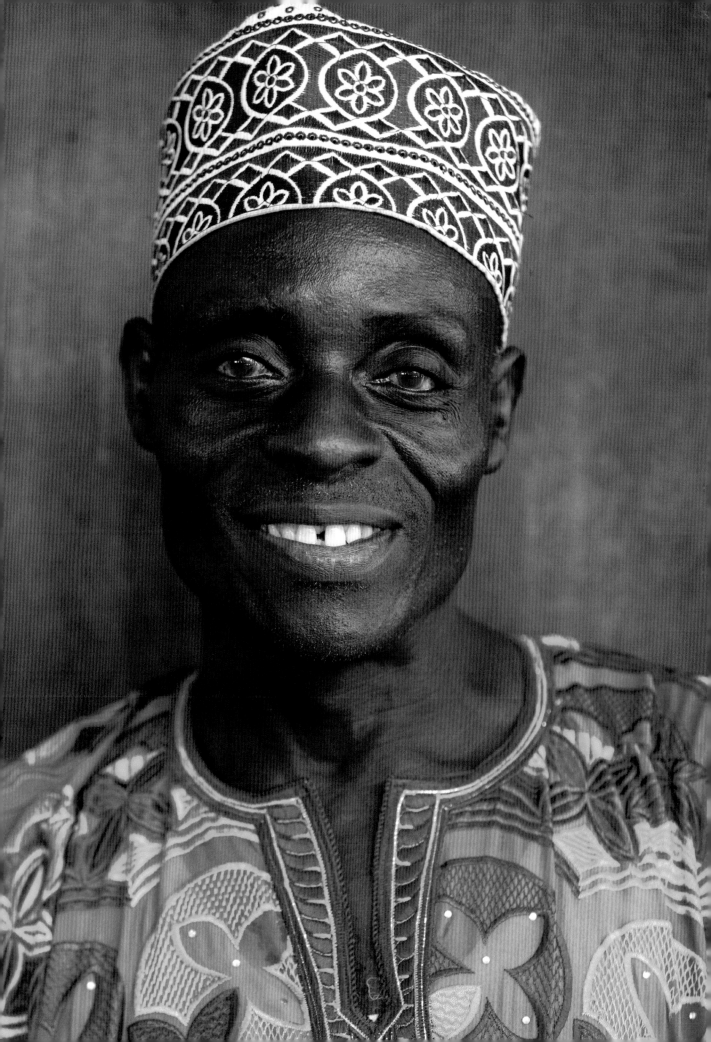

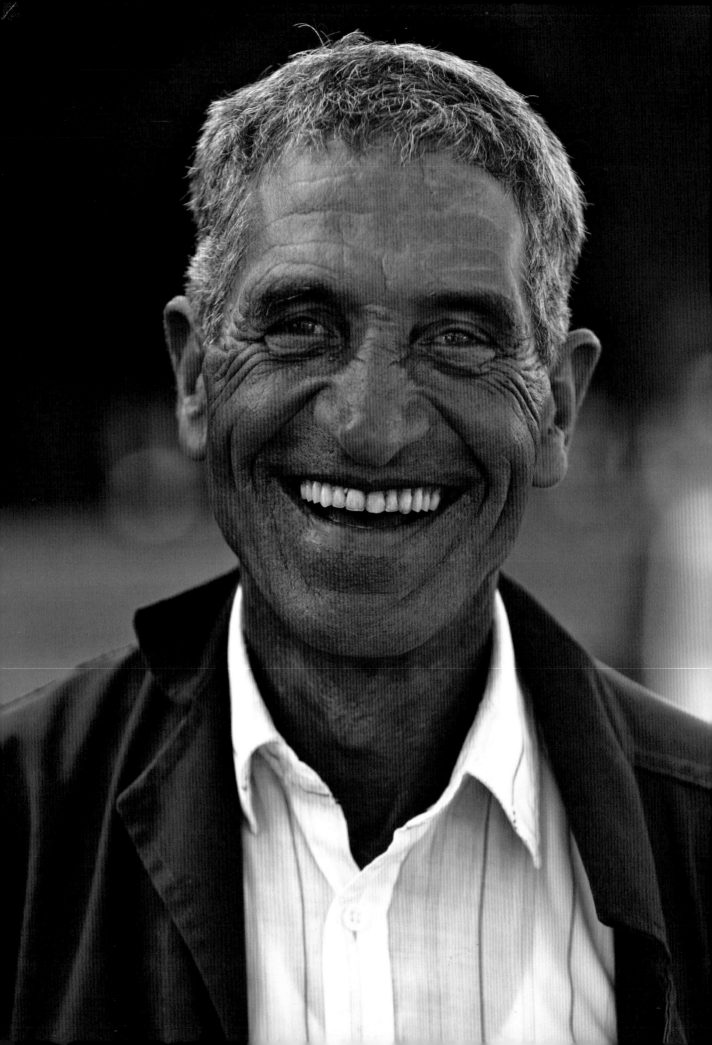

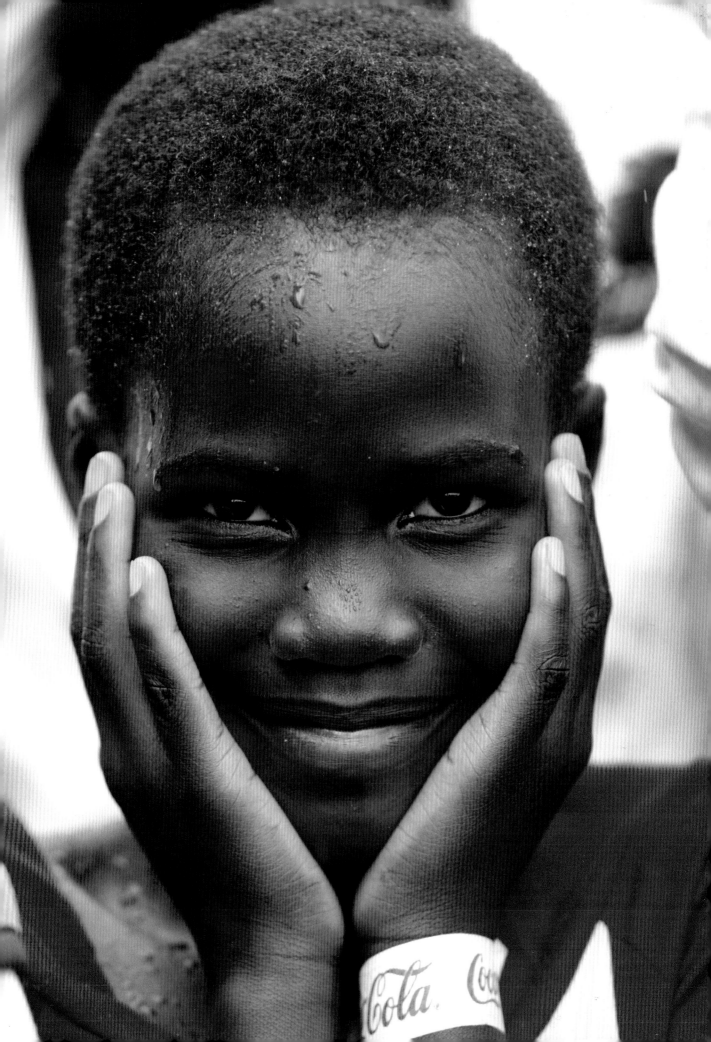

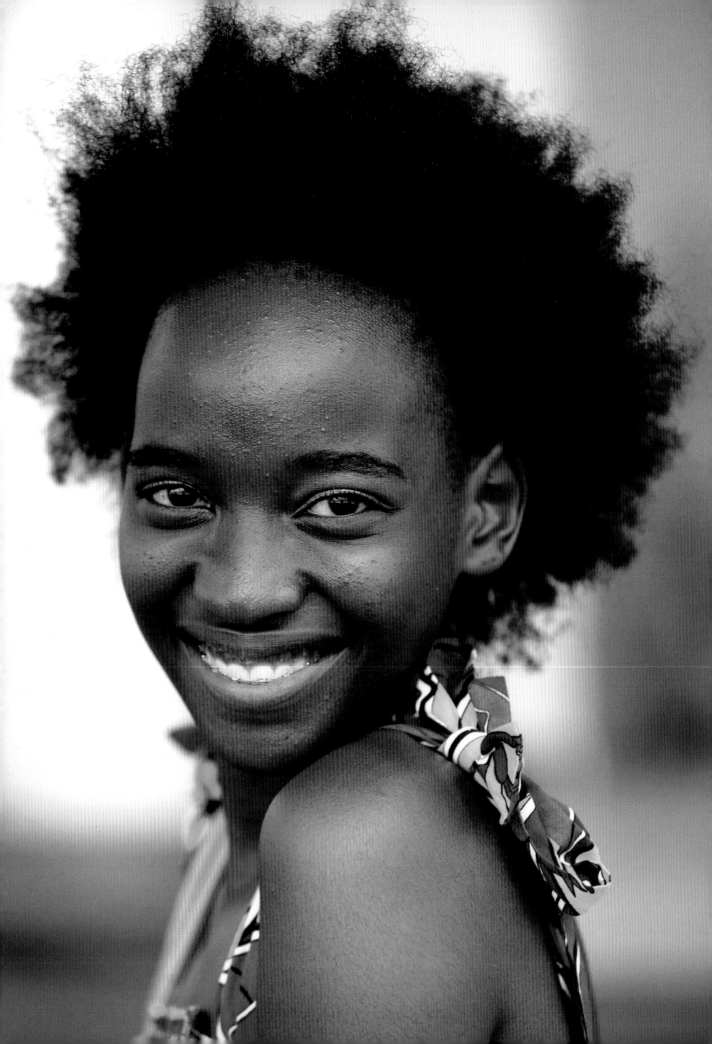

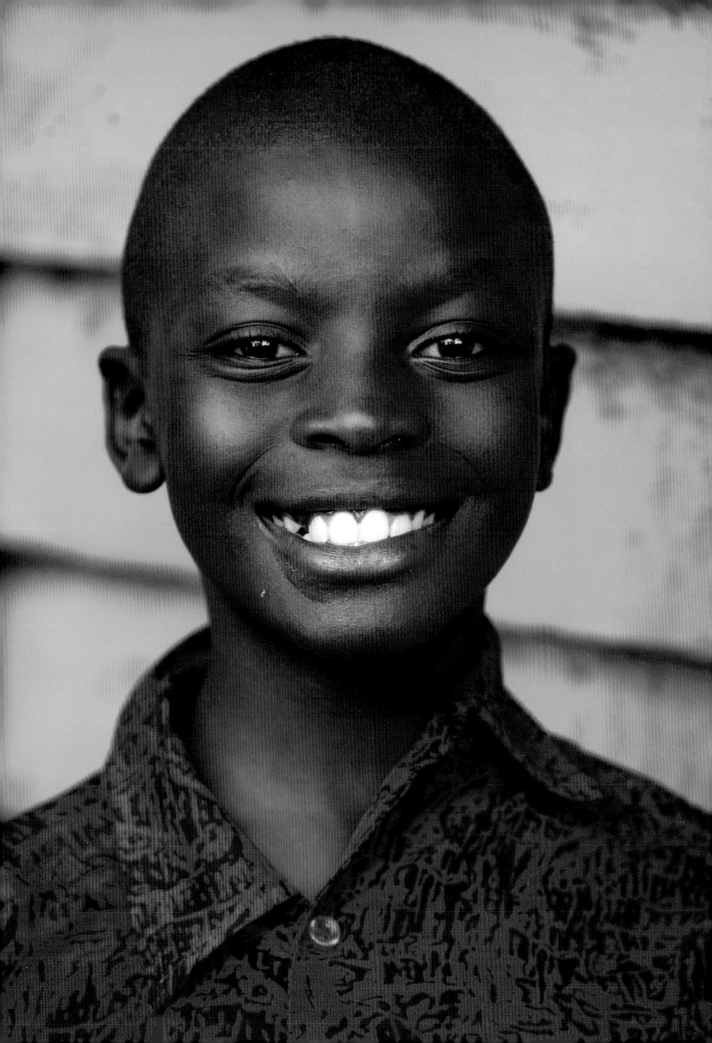

A smile is a moment of enlightenment

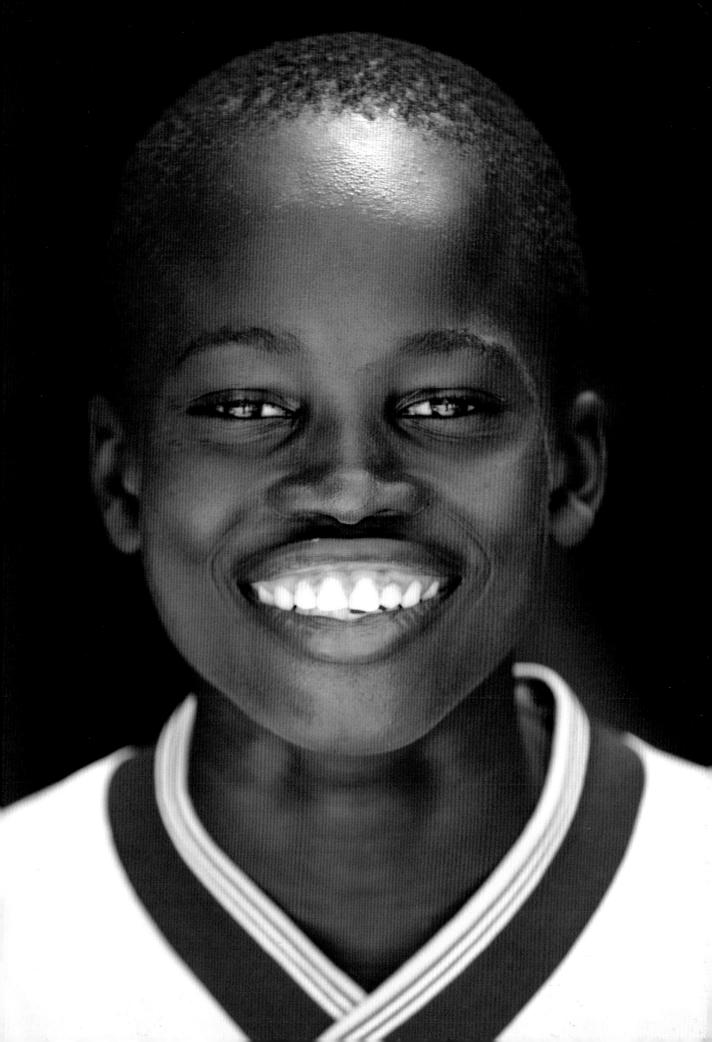

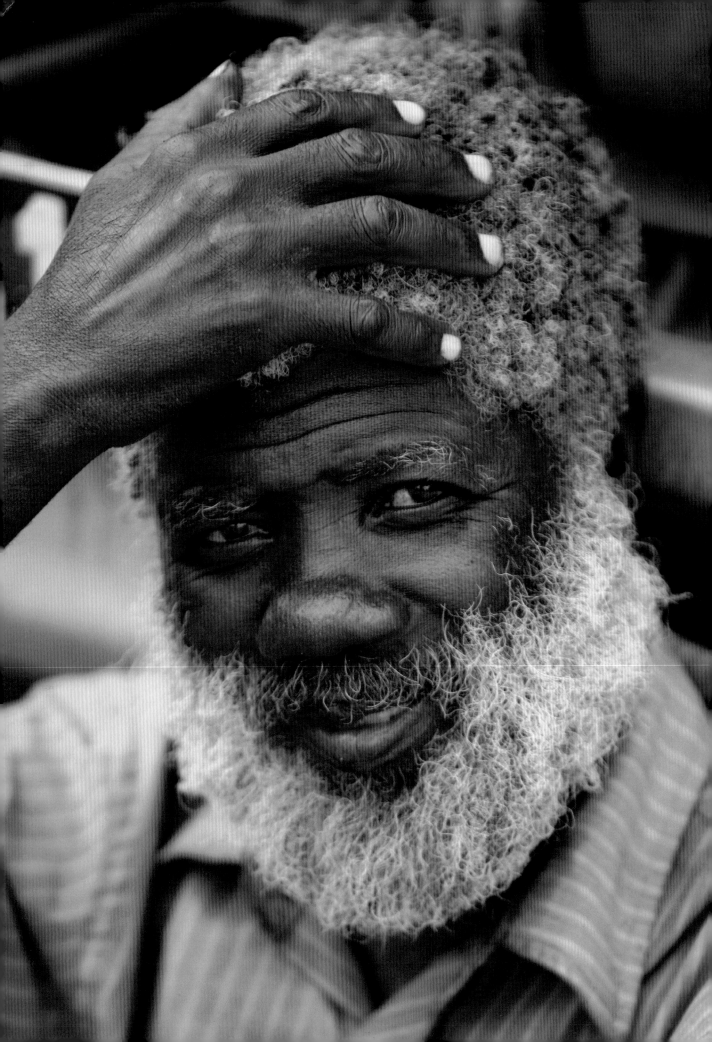

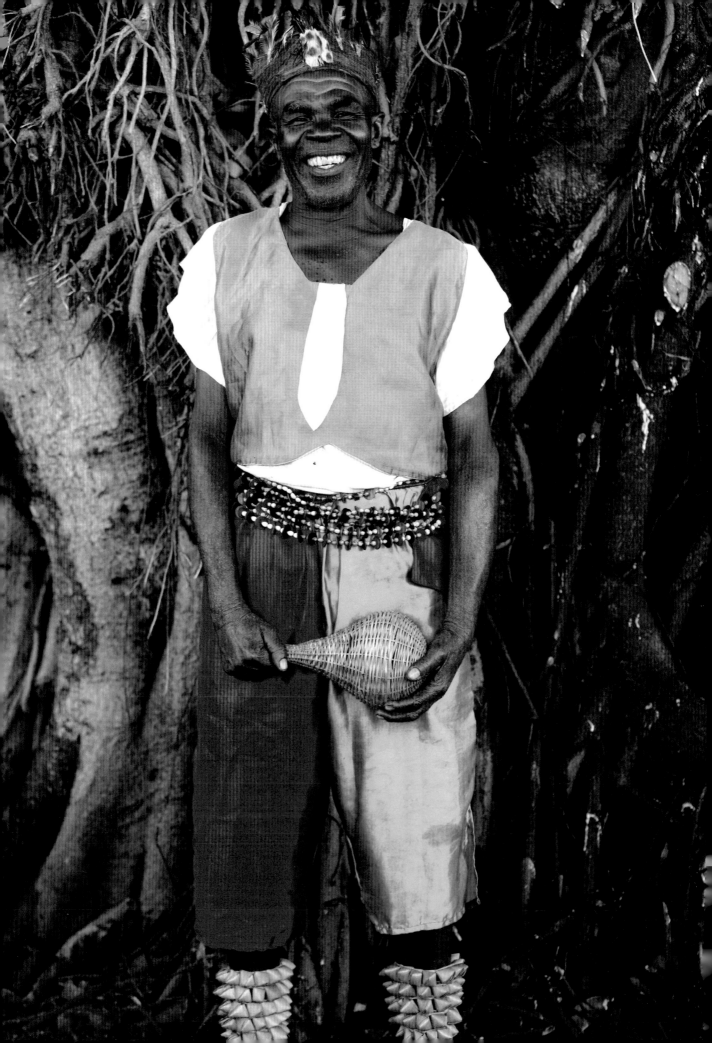

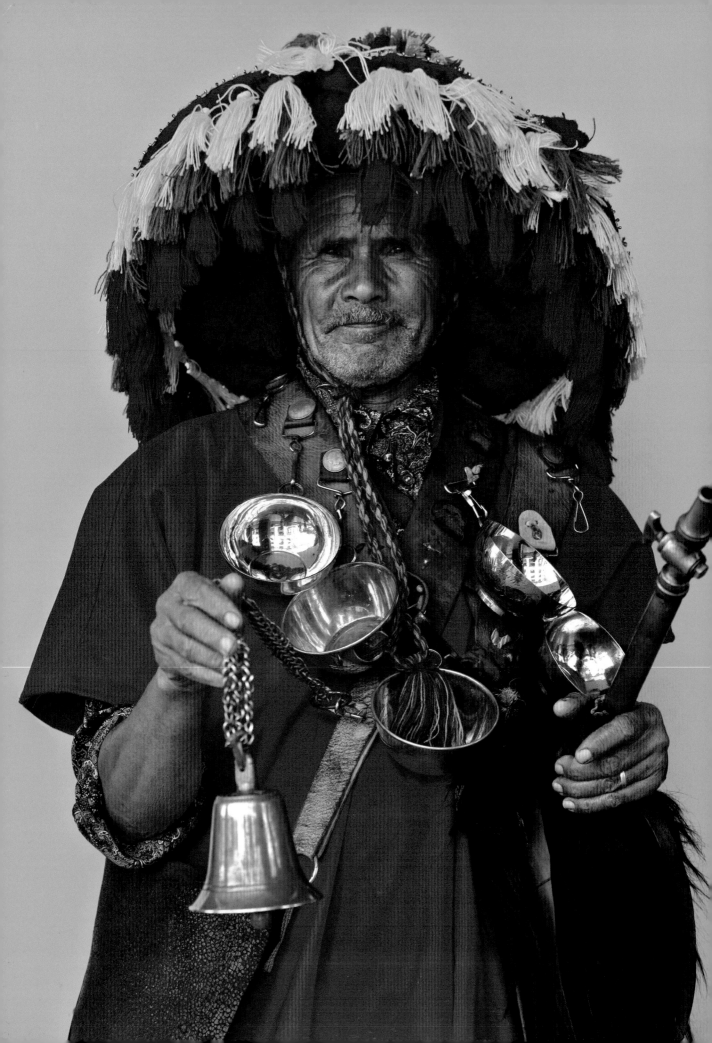

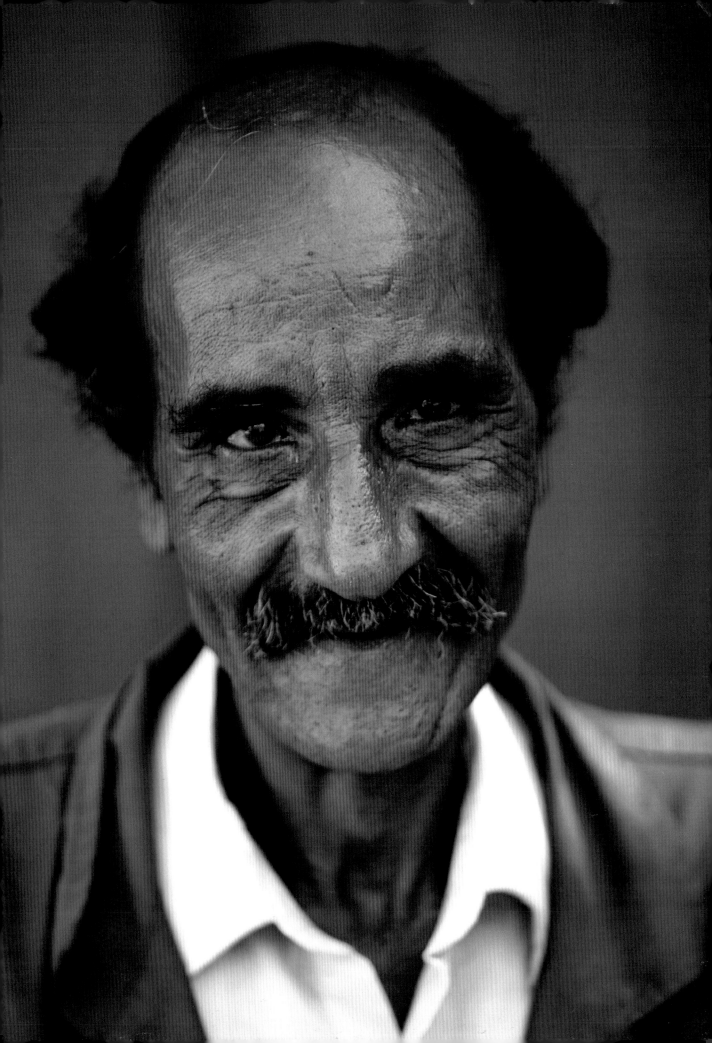

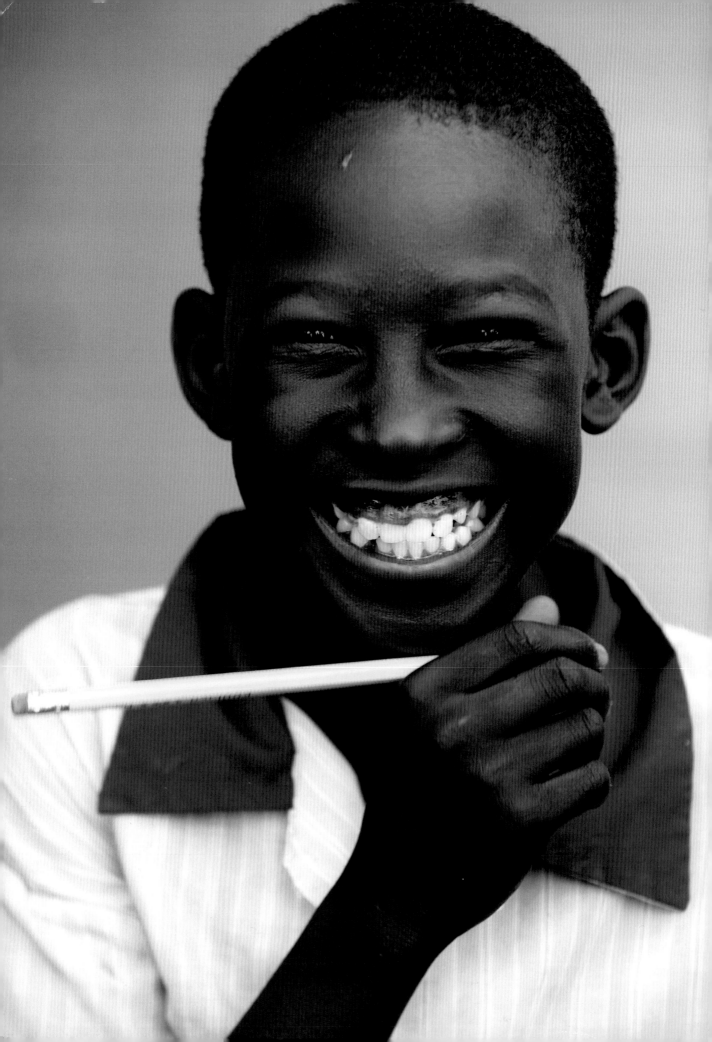

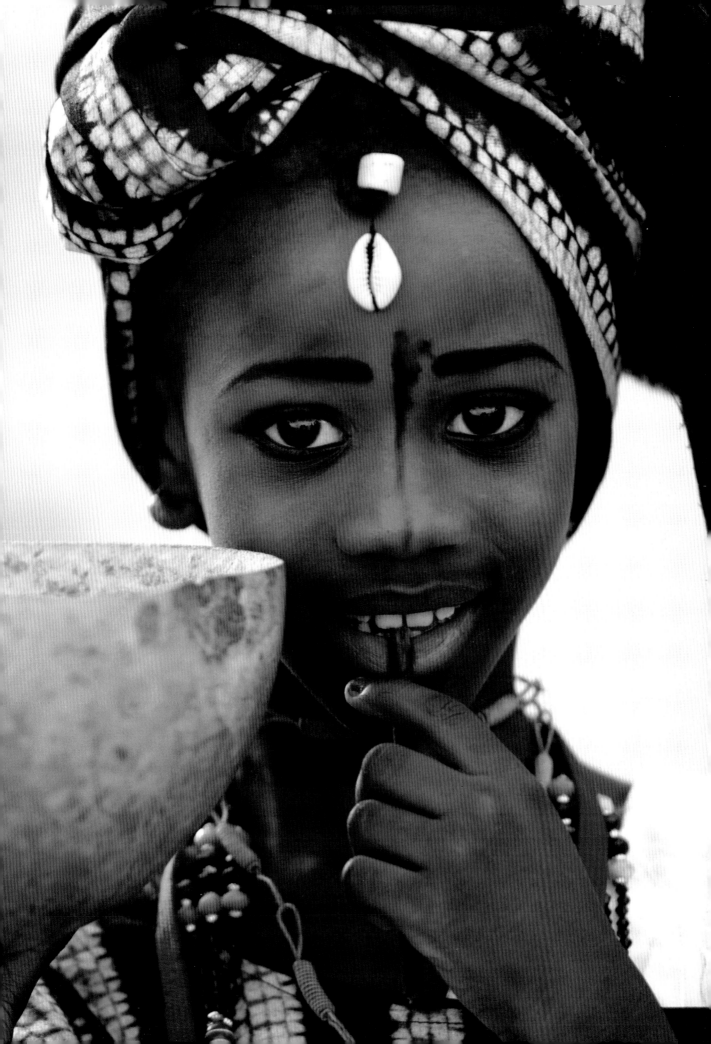

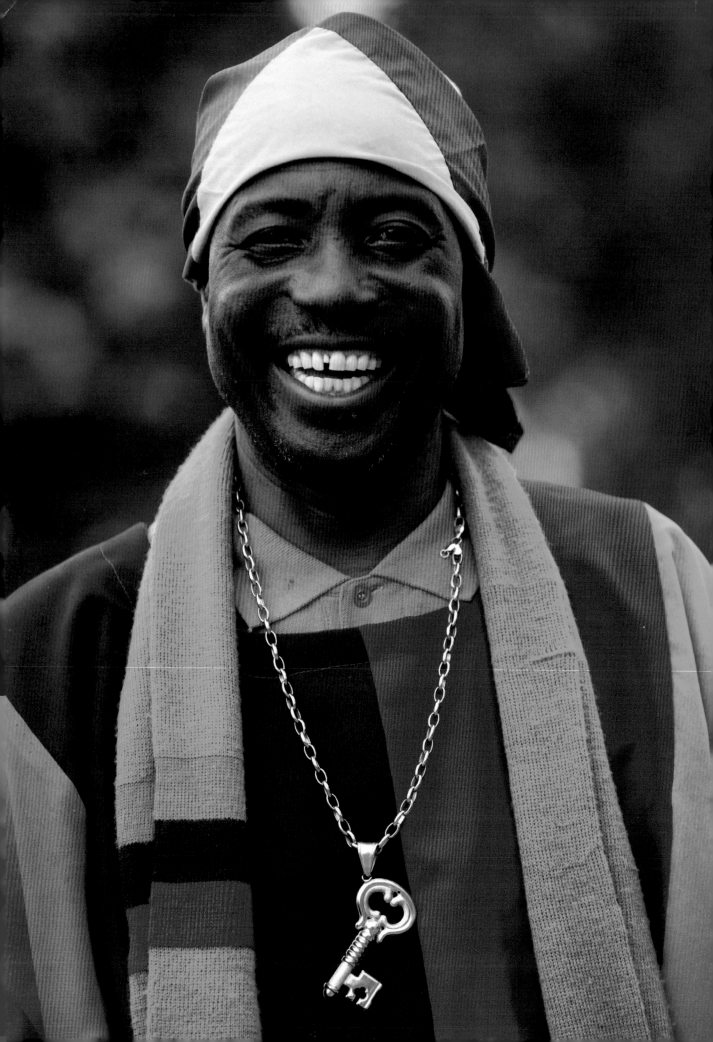

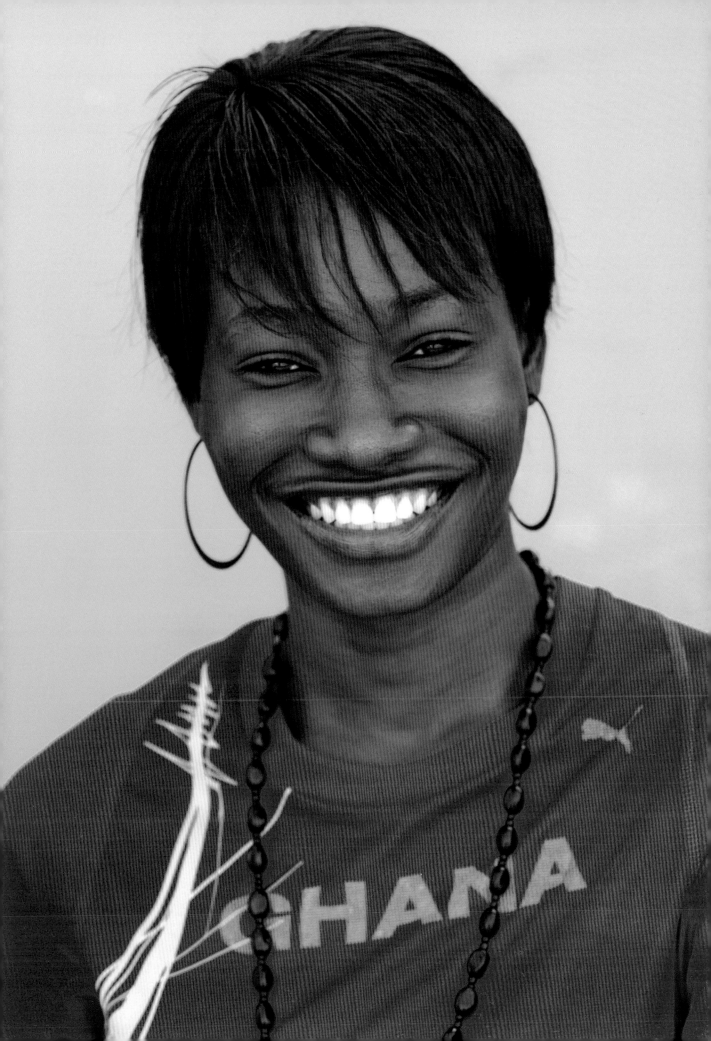

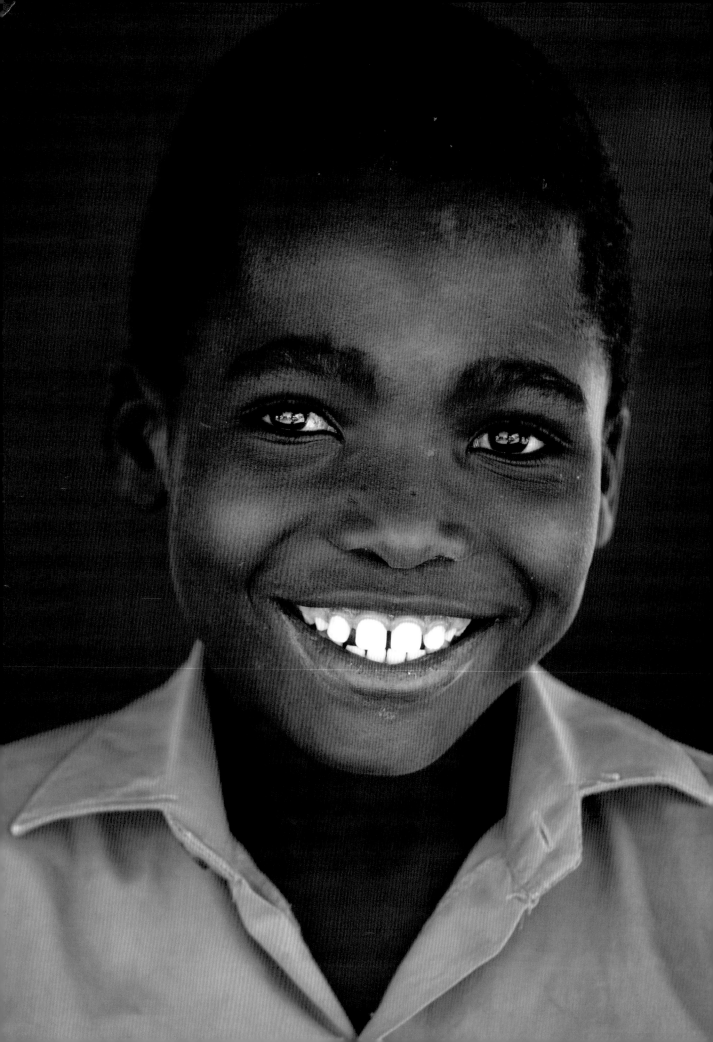

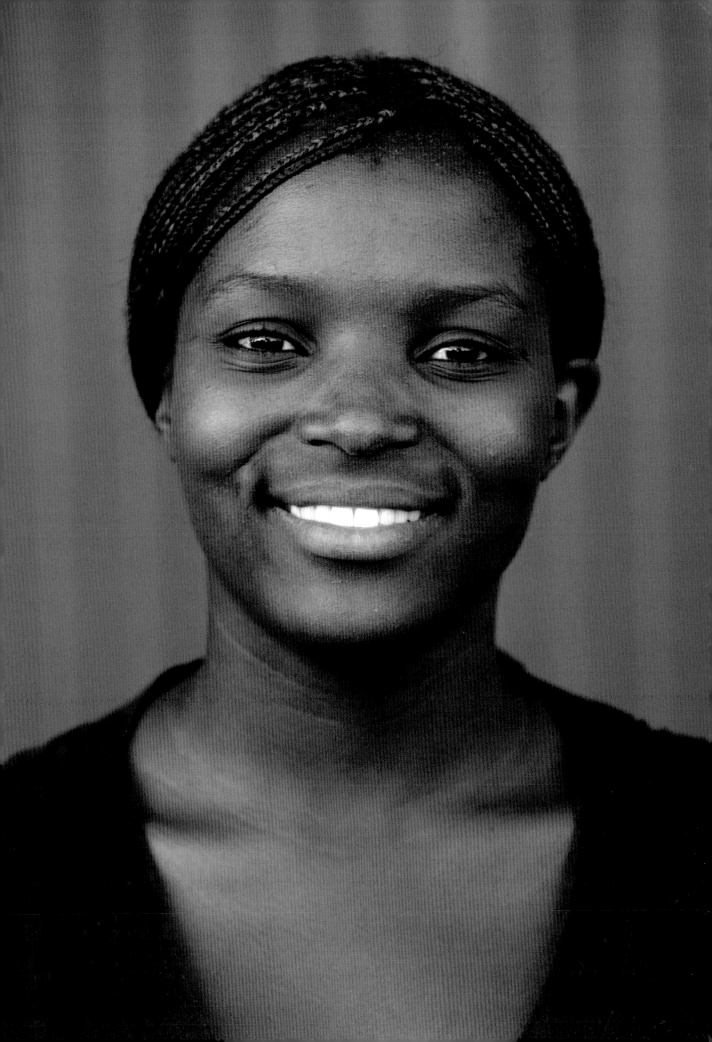

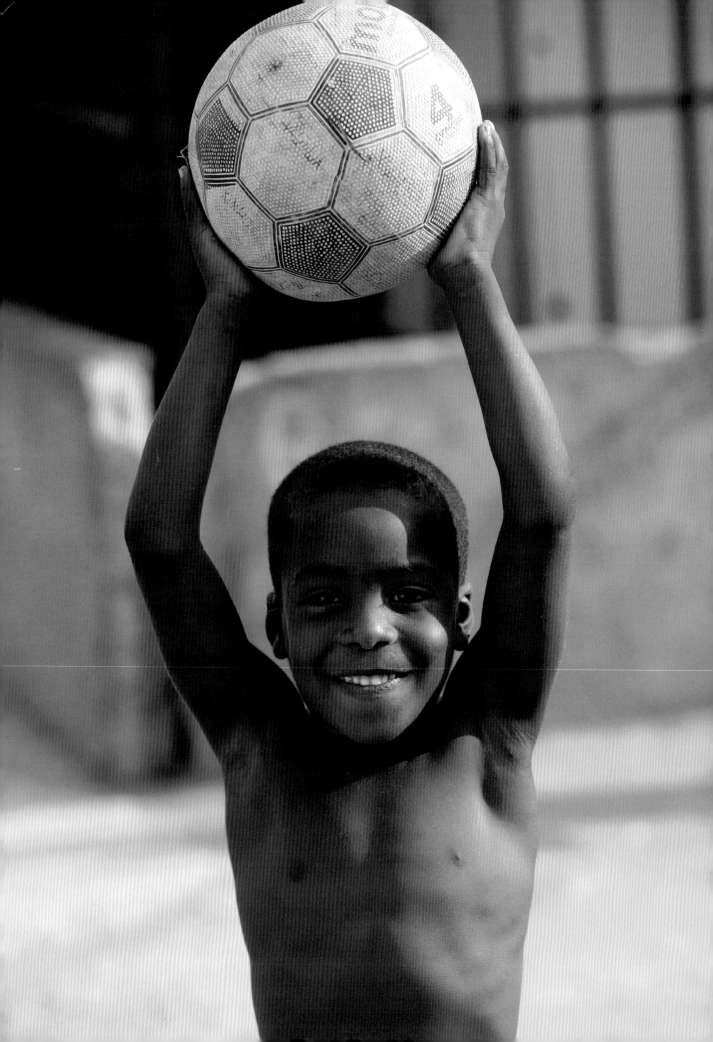

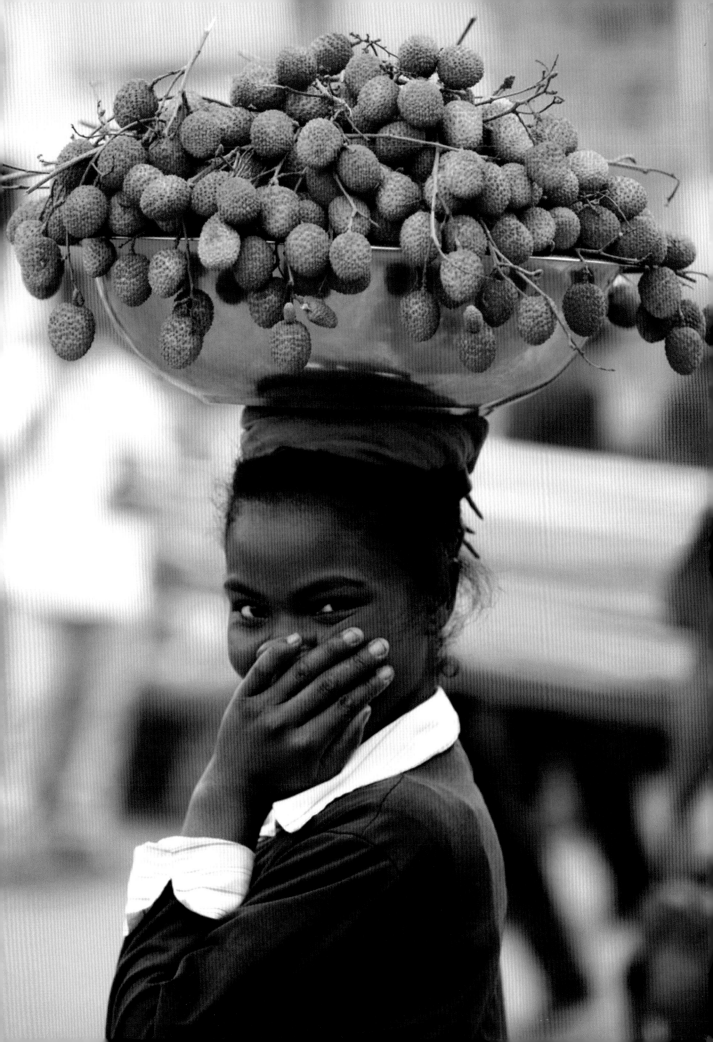

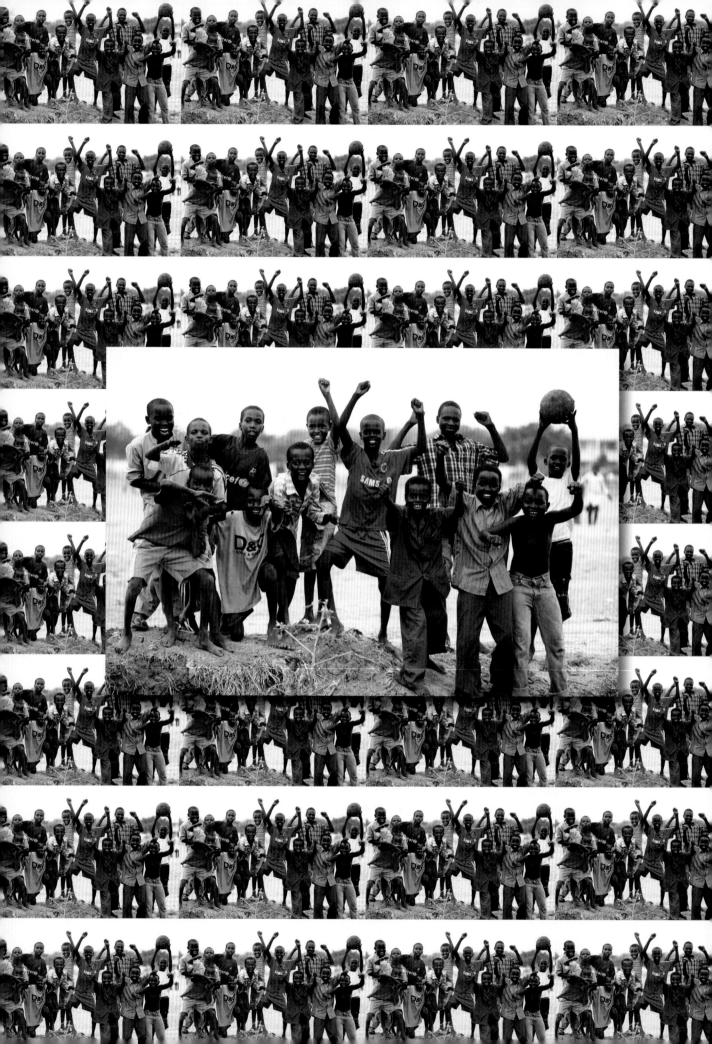

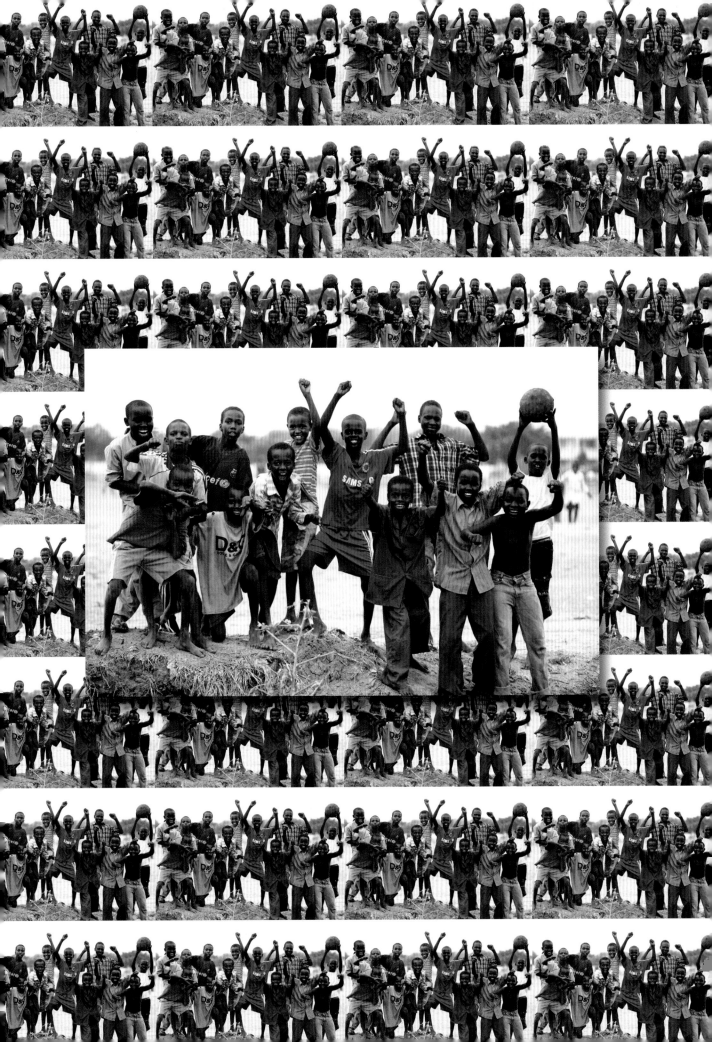

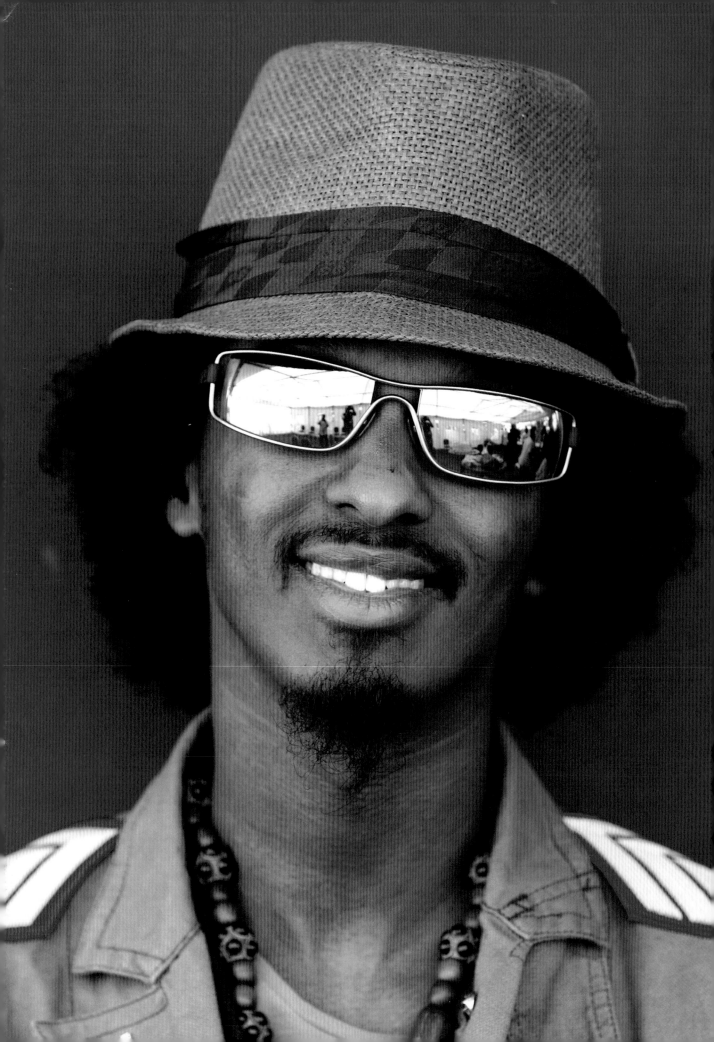

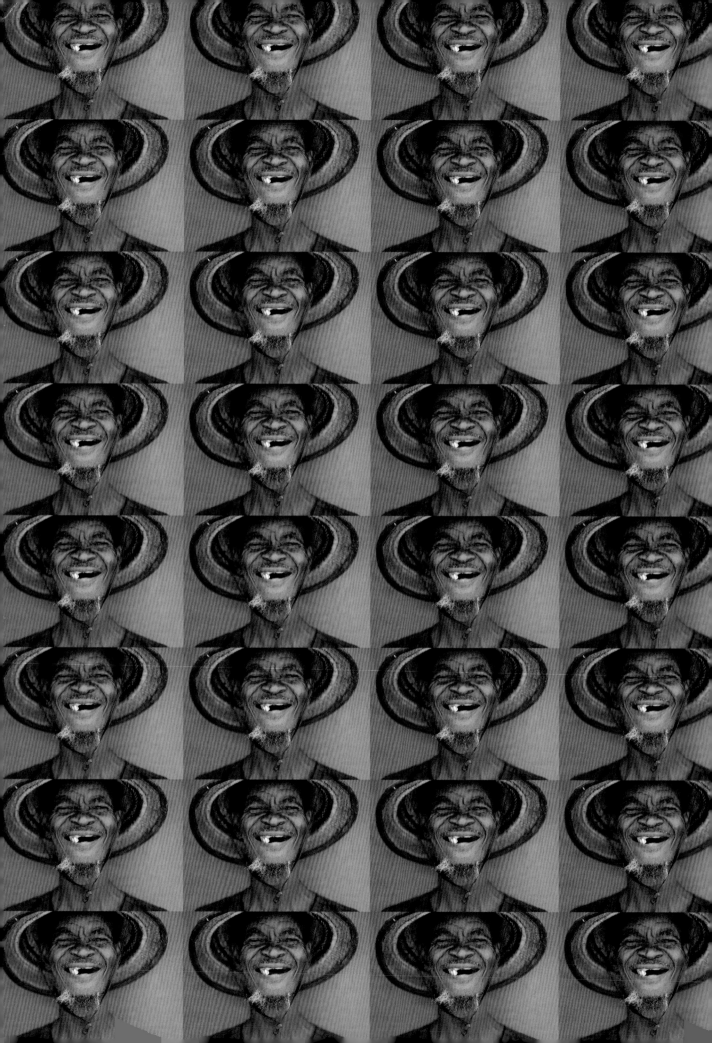

And laughter a true moment of happiness

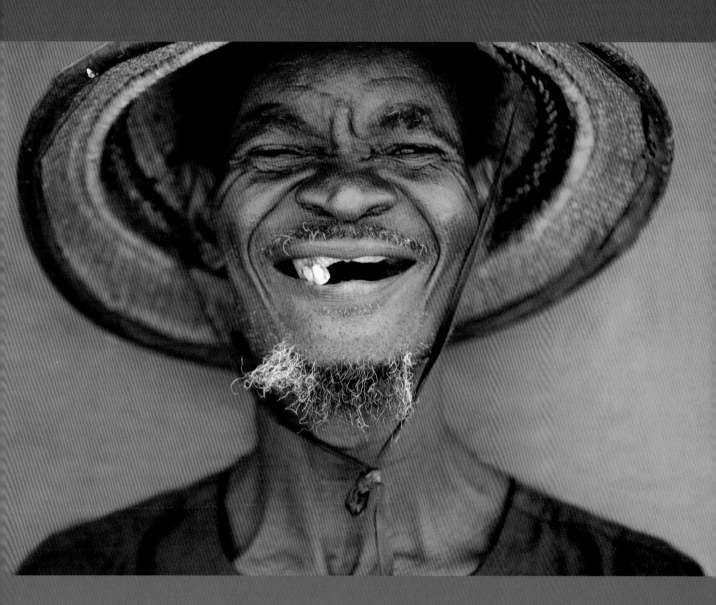

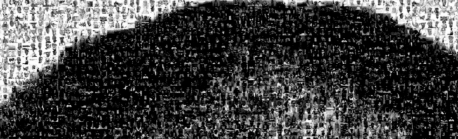

I came across this girl outside the state house in Equatorial Guinea. She had the most magnificent hair, and the light was perfect. To me, her expression brilliantly captures the essence of this book.

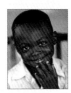

Lagos, Nigeria, is one of the fastest-growing cities in the world. Young children in Lagos, like this boy, will have many more opportunities in the years to come. This child was playing with his friends and family after viewing the World Cup Trophy. He was shy and tried to hide his smile. His mother kept moving his hand away from his face. I got this shot just as he brought his hand down and his face lit up.

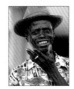

I met this man outside the airport hangar in Guinea-Bissau. He was standing with his friends in conversation. I noticed he was wearing a shirt with Zinédine Zidane, the French soccer star, and I asked him, *"O que felicidade?"* ("What is happiness?"). He answered with this smile.

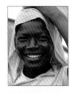

Many families across certain parts of Africa have to walk great distances each day for clean drinking water. This teenage boy was carrying large buckets of water home to his family in the Central African Republic. He told me that he makes this trip twice a day.

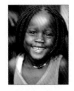

A friend and I went on a last-minute adventure tour in the capital of Guinea-Bissau. We stopped along the side of the road to photograph a colorful crowd. This little girl was among a large group of children who were fascinated by my camera.

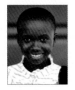

This girl in Dar es Salaam, Tanzania, was shy at first, so I let her see her photo on my camera. She had never had her picture taken before.

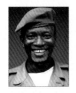

This man in São Tomé, an island nation off the western equatorial coast of Central Africa, was part of the Presidential Guard.

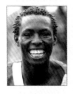

This is one of my favorite images from the trip. We had just landed in the Central African Republic. Our plane had popped a tire during a rainy landing, and we were all out of sorts. This dancer greeted us with such excitement that we were completely carried away by it.

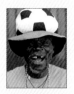

This man had just seen the World Cup Trophy at the Nyayo National Stadium in Nairobi, Kenya.

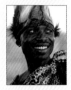

This dancer in Kenya had just finished performing for Mwai Kibaki, the country's president.

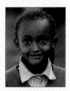

This Somali child was on his way home from school in Kibera.

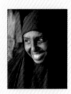

A Somali woman inside her shop in Kibera.

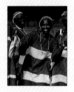

I got a thumbs-up from this woman, who was part of a dance troop performing in the national stadium of Gambia.

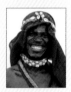

A traditional dancer in Gabon.

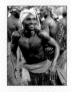

When we arrived in Congo, a troop of dancers performed song after song for us. This man kept dancing long after the music ended.

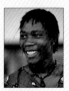

This drummer greeted us on the runway in Guinea-Bissau.

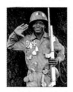

This man was pacing outside our venue along the Congo River, between the Central African Republic and Congo. I asked him what he was doing. He responded, "Didn't they tell you? I am here to protect you." I told him, "You are the Don Quixote of Africa."

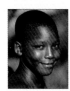

The island of Cape Verde feels like Brazil. The people there have a laid-back lifestyle. Lovers ride bikes at sunset. The beaches are beautiful, the food is amazing, and there is constant dancing. This boy had just left school and was already at the beach with his family.

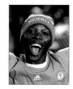

This Nigerian soccer player had just seen the World Cup Trophy for the first time. He said he was sure he would now score goals for days.

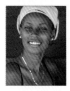

This woman went to see the World Cup Trophy at the national stadium in Burundi.

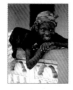

On her way home from school, this young girl stopped to get water for her family outside Banjul, the capital of Gambia.

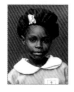

A schoolgirl in Lagos, Nigeria.

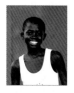

This large purple garage door is in Abidjan, Côte d'Ivoire. I asked this local boy to stand against it for his portrait.

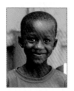

The innocence of this child in Guinea-Bissau reminds me of Secretary of State Hillary Clinton's quote: "There is no such thing as other people's children."

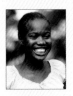

This girl in the Central African Republic refused to smile because she didn't believe she had a nice smile. I told her I wouldn't move until she smiled and let me judge, and then I made a funny face.

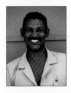

Thanks to this young South African flight crew member, who builds planes for fun, we safely completed our ambitious African safari, traveling to fifty countries in seventy-five days.

This worker was on a break on the island of Cape Verde.

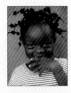

As we were leaving Congo, I saw this young girl at a distance. I jumped out of a moving truck to photograph her in front of the magenta wall.

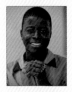

This young student clasps his hands in gratitude after viewing the World Cup Trophy in Liberia.

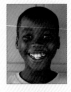

A soccer player in Togo.

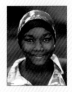

A schoolgirl taking shade behind the national stadium in Niger.

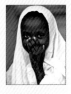

A girl at the national stadium in Niger.

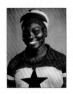

This Ghanaian woman wore her colors with pride.

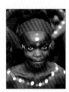

A young Congolese dancer.

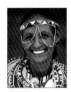

A woman in Nairobi, Kenya.

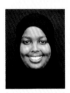

This Somali woman goes to school and works in Nairobi.

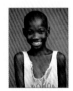

A young girl from Côte d'Ivoire.

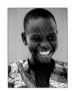

I saw this girl waiting for the bus after class in Burkina Faso.

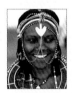

A dancer in Kenya covered in ornate Maasai beads and a headdress.

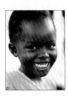

A young girl in Liberia.

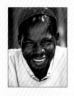

A huge soccer fan from Burkina Faso.

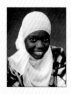

A schoolgirl outside the national stadium in Gambia.

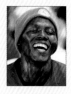

A hardworking drummer in the presidential gardens, Ghana.

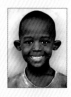

A boy from Côte d'Ivoire.

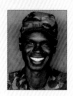

A soldier in Luanda, Angola.

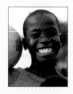

A boy in Zambia.

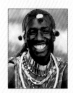

What a smile! This Kenyan man could jump incredibly high. He was bouncing and singing nonstop in sandals.

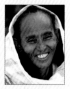

I watched this woman dance with a troop in the capital of Eritrea.

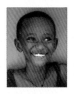

This child followed me around for hours as I photographed hundreds of people in a Burundi stadium on a very hot day. When we finished our rounds he leaned up against this wall. I asked him if he was happy and he just smiled. Sometimes words get in the way.

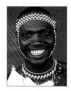

Burundi drummers balance massive handmade drums on their heads while singing, dancing, and drumming in unison. The sound is hypnotic. I asked this drummer where his happiness comes from. He said it came from doing what he loves.

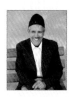

A Tunisian man in Morocco.

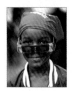

This boy in Kampala, Uganda, had just seen a 3D movie for the first time.

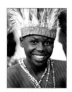

A young dancer in the Central African Republic.

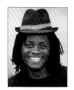

I met this musician in Mozambique, just after Michael Jackson had passed away. The city was filled with dancers in black hats and white gloves paying tribute.

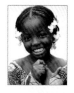

A young girl in Côte d'Ivoire.

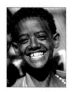

A jubilant soccer player from Eritrea.

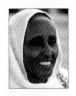 A woman in Djibouti.

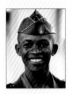 A soldier greets us at the airport in the Central African Republic.

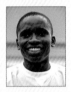 This soccer star in Luanda, Angola, told me that he plans to play overseas and make his family proud.

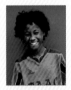 This young athlete outside the national stadium in Rwanda told me, "I can do anything I set my mind to."

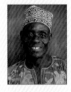 A man in Benin.

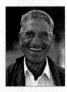 This Algerian photographer, who was taking pictures in the streets of Casablanca, Morocco, let me turn the camera on him.

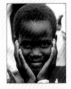 A young girl in Kampala, Uganda, excitedly waiting for K'naan to take the stage.

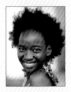 A young woman in Botswana, moments after she'd seen the World Cup Trophy.

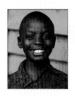

A boy in Kibera, Kenya.

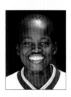

A soccer player in Kigali, Rwanda.

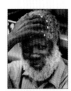

A man in Angola.

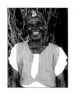

This dancer posed in front of a massive tree along the Conga River.

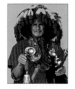

What are the chances of bumping into this man in front of a mint-green background? This is the photographic magic that occurred in Morocco.

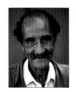

A man in Casablanca smiles at the end of his workday.

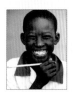

This Ghanaian student stopped on his way home from school to do his homework.

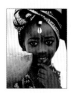

A young Senegalese girl greeted us on the runway with a bowl of rice and a blessing.

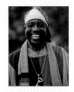

This proud man wears the colors of Zambia.

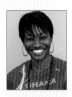

A woman in Accra, Ghana.

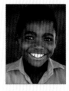

A young soccer hopeful in Dakar, Senegal. He hadn't seen the trophy yet, so I snuck him in the back door and walked him to the front of the line. His eyes lit up.

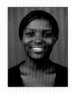

A Namibian woman.

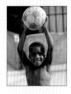

There are four million children in Angola. Many dream of becoming professional soccer players.

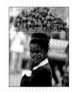

A girl in Antananarivo, Madagascar.

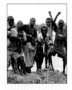

Our expedition in Chad led us through many parts of the capital city. One day, when we were returning to our hotel, we came across an open field that had about a dozen soccer matches going on. A group of young players insisted I photograph their team.

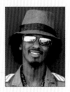

K'naan, in the makeshift greenroom in Addis Ababa, Ethiopia, before performing "Wavin' Flag." Six months later the song was a global sensation. It had hit number one in eighteen countries and had become an anthem for two billion soccer fans.

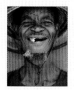

This man in Burkina Faso had never had his picture taken before. When I showed him his image on my camera, he burst into a magnificent smile that was downright contagious. It was one of the most memorable moments of this adventure.

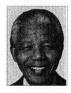

A mosaic portrait of Nelson Mandela—a man whose spirit helped inspire this project—created with portraits I took during my journey through Africa.

Acknowledgments

Thank you first and foremost to the African people. Your inherent optimism and happiness are an inspiration to the world.

Thanks to Muhtar Kent, chairman and CEO of the Coca-Cola Company, and Sepp Blatter, CEO of FIFA, for investing in the African people and planting the seeds for the future.

Special thanks to my Turkish brother Umut Ozaydinli of Deviant Ventures and Emmanuel Seuge of the Coca-Cola Company for taking a chance on a big idea, and for their confidence that something could be created that would change the world.

Thanks to Coca-Cola CMO Joe Tripodi, Shay Drohan, Cristina Brondowski, Scott McCune, Amber Steele, Coca-Cola South Africa CEO William Egbe, Amanda Mancia, Roger Gauntlett, Lorna Sommerville, Bachir Zeroual, and the 146,200 global citizens Coca-Cola employs every day all over the world, and many more at Coca-Cola who dedicate their lives to campaigns that inspire.

Also at FIFA, thanks to Emmanuele Maradas and Jan Schetters. FIFA truly represents an organization that brings the world together to celebrate our commonality. Thank you for your dedication to growing the game of soccer worldwide and your inspiration to billions of hearts and minds each day.

Special thanks to Dill Driscoll, Kelly Kozlowski, Manny Diaz, Daniel Dao, Simon Isaacs, and everyone at Ignition for your support during and since the tour.

Special thanks to Brandon Bregman and Global Aviation for planning and safely completing the fastest African safari ever attempted.

Special thanks to Canon for its commitment to products that empower unlimited creativity in space and time. To be on the move for sixteen-hour days across each African terrain taking portraits of heads of state and shooting pictures

while hanging out of helicopters and traveling in jets and motorcades, and during concerts, all to capture 150,000 images in under eighty days, is the ultimate test of endurance and high performance.

Special thanks to Brian Bridgeon and the SanDisk Corporation for all your support. The memory, speed, and reliability of your resources gave me the peace of mind and confidence necessary to focus on capturing the positive image of a continent.

Thanks to Julie Grau and Cindy Spiegel and everyone else at Spiegel & Grau/ Random House for seeking books that inspire and change the way we see the world.

Thanks to my mother, Rosalyn Guarini, and my father, Joseph Patuleia, two of the most positive people in the world.

Additional thanks to Jacquelyn Mayfield, Jennifer Rosalyn Patuleia, Saunders Moore, Ron Menard, and Evelyn Guarini, Richard Guarini, and family. Thanks also to Guissepina Fantoini and Roberto Barbarulo, who seeded me with a positive image of Somalia, and Somalita Banane, Brando, Olympia, Antonio, and family, and Sylvia Ogonaga. I would also like to thank supporters of the project, including but not limited to Barry Williams, Joe Belliotti, *The 50th Law*, Robert Greene, Curtis "50 Cent" Jackson, Chris Lighty, Laurie Dobbins, Keesha Johnson, Marc Gerald of the Agency Group, Michael Carlisle of Inkwell Management, Patricia Matson and Edward Gottesman, Franklyn Pintado, Sharon Patrick, Safi Bacall, Loretta McCarthy, the Lader family and Renaissance Weekend, Adrienne Cleere, Mickey and Leila Strauss, Claire and the Scoville family, Jim Caparro, Andrew C. Cooper, Boyd Matson and Betti Hudson, Jacob and Donna Scherr, Henry Buhl, Steve McCurry, Peter Buffett, Tory Burch, Chris Burch, Joe Lonsdale, Pat Mitchell and the Paley Center for Media, ESPN, Geoffrey Mason, the South African Consulate, Matthieu Cochets and family, Charles Barthelemy and family, Baron Fortsmann and family, Peter Tunney, the Hemingway Gallery, NBC News anchor Erika Tarantala, Lucan Nathan, Eugene Baah, Ely Fretz, Priyanka Sharma, Milton Speid, Dan Eldon, Kathy Eldon, Michael Bedner, Amy Eldon Turtletaub, Rocco Ancarola, Dino Lacapra, Param Singh, 212 Media, Laurence Chandler, Josh Cooper and Proof 7, Taylor Olson, Lauren Solomon, Rima and Roshan Shah, Rajiv Dandona, Rikki Dandona, Vijay Paintal, Gregg Freishtat, Gunnar, the Michelsens, Patrice Motsepe

Foundation, Colin Gayle, Fatima, Leah Marville, Ruth, the Nelson Mandela Foundation, K'naan Warsame and the Somali people worldwide, Sol Guy, Rayzac, Kiersey, Nabil Elderkin, the Madison Square Boys and Girls Clubs of New York City, Pankaj Shah, Scott Harrison and Charity Water, Andrea Piana, Marco Piana, the African Rainforest Conservancy, Katie McLetchie, Christy Turlington, Peter and Nejma Beard, Ohad Maiman, Eytan Rockaway, Matt Greenberg, Matt White, Daddy O, Jesse Barton, Cedric Singleton, Rontese Miller, ROAR Africa, Jayme Illien and the Illien Foundation for Children, Atti Worku, Maggie Sands, Shawna Hamilton, the Seeds of Africa Foundation, Joseph Landau, Fine Binding, Alan Levanthal, the Schulberg family, Ellis Levine, Alan Rish PR, Scott Lipps, Ben Agin and family, Ysiad Ferrareis, Daya Aldafer, Tetyana Nosenko and family, James Mormile and the Mormile-Iovine family, the KIN family, Mark Thorald Koren, Ashley Maher, Ashleigh Snead, James Kaminski, Isaac Koren, Sophie Ward, Madeleine McRae, Shakerleg, Tracy Zamot, John Mazlish, Whitney, Ayla, Christian, Cresta Huguenot, Elliot Resnik, Shezelle Weekes and family, Kameron Corvet, Selma Ahmed, Joseph Llano, Sajda, Spencer Morgan, *The New York Times*, Shanee Pink, Naquan Smith, Ellie Clougherty, Anne Clougherty, Eve Ensler, Donna Karan, Richard Porter Thayer, Damasa Doyle, Alessandra Von Eikh, Marvin Amberg and Caseable, Prince and Jacob, Lisalla Montenegro, Christian Alexander, Jesse M'bengue, Kate Litvinov, Chloe Aumtio Motte, Ed Ponsi, Renata Alves, Camilla Ibrahim, Jodi Shapiro, Eyen Chorm, Lorenzo Martone, Misha Nicole, Eve Gardner, Joe Roland, Jesse Woods, Aitana Novoa, Servrin Anderieu-Dellile, Nianga Ninga, Alex McCarthy, Alicia Henry, Charlotte Gray, Sophie Isherwood, and Ayesha Siddiqui.

Special thanks to Permanent Representative of Iraq to the United Nations Dr. Hamid Al-Bayati, United Nations Secretary-General Ban Ki-moon, and President of the 66th Session of the UN General Assembly Nassir Abdulaziz Al-Nasser. Your dedication and persistence for Gross Global Happiness is an example to the world.

My gratitude,
Joseph Peter